DAVID BAILEY

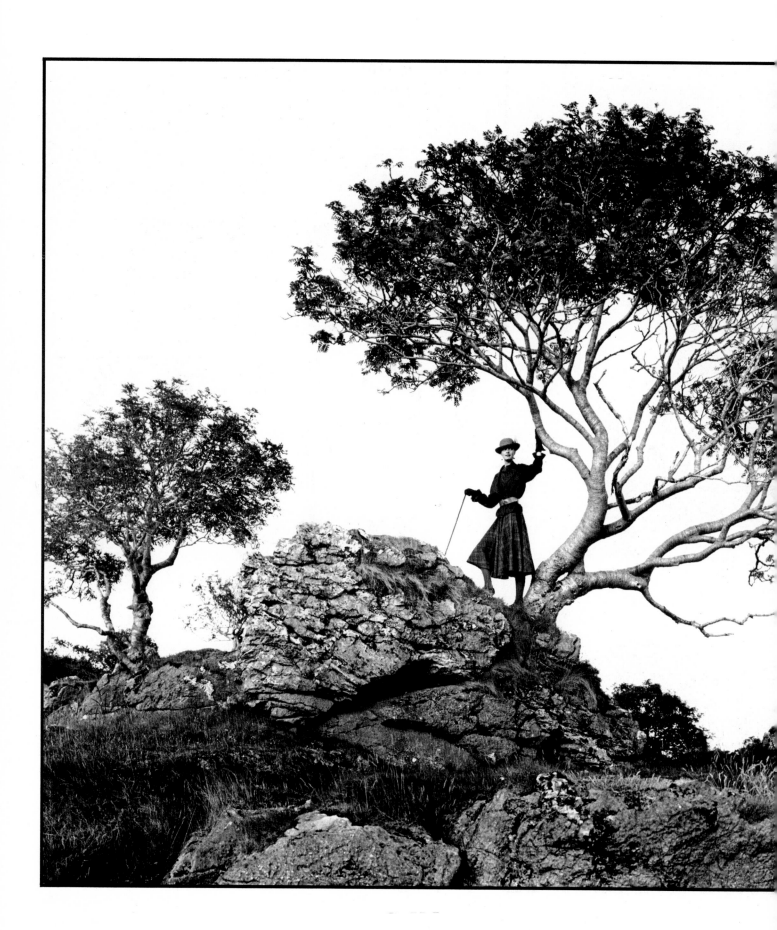

THE GREAT PHOTOGRAPHERS

DAVID BAILEY

Martin Harrison

COLLINS

DAVID BAILEY

by Martin Harrison

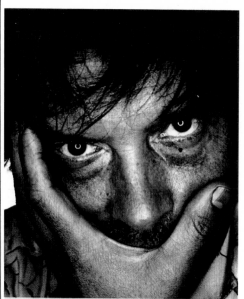

David Bailey, self-portrait, 1982

Historian Reyner Banham has described the rise of Pop Art in Britain as 'the revenge of the elementary schoolboys'. David Bailey shot his first cover for *Vogue* magazine in 1961, at exactly the moment when the Pop painters in London and New York were enjoying their initial media success. In much the same way as the anti-class, anti-paternalism stance of the Pop artists broke down the elitism of the British art scene, Bailey's fresh and uncompromising approach to fashion photography helped to destroy the notion that fashion was an effete and remote pastime of the rich.

He did this firstly by not treating his models as mere clothes-horses. He brought sex into fashion photography, and always aimed to make his women look desirable. At first his photographic techniques were not especially innovatory. From the outset he experimented with many different camera formats and lighting methods. This fascination with the creative possibilities afforded by lenses of differing focal lengths and varying film sizes has stayed with him until today. It is perhaps both a strength and a weakness. It is certainly the almost inevitable outcome of his restless, relentless and quite incredibly energetic commitment to photography. He was, and continues to be, full of both contradictions and surprises. For example, he has admitted the wisdom of the advice given to him by Alexander Liberman, Art Director of American *Vogue,* when he first visited New York in January 1962: 'You need more direction. You're all over the place.'' Possibly Bailey did take some notice of Liberman, because during 1962 his fashion photographs gradually became more strongly graphic, less complex than they had been. And yet recently he has remarked on how, when photographing the actor Jack Nicholson, he switched from roll-film to a 5×4inch sheet film camera halfway through the session and immediately provoked in his sitter a different, far more serious and formal pose and attitude.

In 1961 Bailey first photographed Jean Shrimpton. Her character and appearance—the way in which she combined sexiness with innocence—made Shrimpton the perfect vehicle for what Bailey was setting out to do with his photographs. They were almost inseparable for three years and became the darlings not only of the fashion world but of the media in general. The early fame Bailey achieved as a fashion photographer, and to a slightly lesser extent as a portraitist, has been a mixed blessing. There is still a tendency, especially outside of Britain, for people to pigeon-hole Bailey as a photographer only of fashions and fashionable personalities. This, with some justification, he resents, since he has never confined himself to any one category of photographic expression. Though commercial fashion and portraiture has largely provided his bread-and-butter, his books (of which there have been nine since 1965) have mostly consisted of non-commissioned work of widely varying kinds.

Bailey's first thoughts of a career in photography were stirred by a keen adolescent interest in birdwatching. (This slightly surprising enthusiasm remains, incidentally, with him today; he still has a large collection of rare and exotic parrots at his house in London.) David Bailey was born on 2 January 1938 in the East End of London, the son of a tailor. His origins were humble but not deprived. World War II meant that his education was seriously interrupted until he was eight years old, and thereafter he showed little interest in academic success. His attempts to photograph garden birds with his parents' box camera were predictably unsuccessful and he dismissed the possibility of being able to learn the technical side of photography. He left school aged fifteen and drifted through innumerable unsatisfactory jobs, mostly in stores and warehouses in the East End of London.

Bailey's main interest was in the cinema, which for many years he visited at least three times a week. The films were mostly American and his youthful vision of Hollywood glamour only served to increase his dissatisfaction with his own drab environment. He was determined to somehow lead a glamorous life himself, though at this stage he had no idea how to set about it. A traditional way of rising above East End origins was to become a jazz musician. 'So I bought a trumpet and prayed to Chet Baker.' But, despite taking trumpet lessons from an experienced musician, Bailey knew deep down that he would not make the grade.

In August 1956, when Bailey was aged eighteen, he was called up to do two years' national service in the Royal Air Force. He served in Singapore and Malaya. It was the first time he had left England, and his radically new environment provided a stimulus to think again about photography. Cameras were cheap in Singapore and he soon bought his first adequate item of equipment: a Rollop, a copy of the 6×6cm Rolleiflex. At first he used it simply to record his surroundings, the landscape, his friends. He became an avid reader of photographic magazines—mostly American—and journals such as *Life*. One image in particular impressed him—Henri Cartier-Bresson's 1948 photograph of four heavily draped ladies on a hilltop at Srinagar, Kashmir. It did not seem possible it was a photograph, he could not believe that such quality could be achieved with a camera. And he suddenly realized that perhaps it was after all possible to learn the technical side of photography.

By the time he was back in London in the summer of 1958 Bailey was absolutely committed to a career in photography. He realized he had much to learn and tried to join a course in photography at the London College of Printing, but his lack of examination success at school meant that he could not be accepted. For several months he was out of work and endlessly wrote letters to the leading photographic studios in London asking for a job as photographer's assistant. At the end of the year he became an odd-job boy for the advertising photographer David Olins. This was a breakthrough of a sort, but he was mostly confined to sweeping the studio floor, making tea and cleaning the boss's car. Then, in June 1959, he was accepted as second assistant to one of London's most respected fashion photographers, John French. John French died in 1967, but in the 1950s had built up a reputation as an innovator in fashion photography techniques aimed specifically at reproduction in newspapers. He was also a very kind man, helpful to beginners, who befriended Bailey and introduced him to the world of fashion. Bailey's eleven months with John French were invaluable. Before leaving the French studios he was allowed to take on commissions in his own right as a photographer and, besides taking fashion pictures for the *Daily Express* and *Daily Mail,* was working for magazines such as *Vanity Fair* and *Flair*.

Bailey says that he learned from John French more about attitudes and how to deal with clients than about photography as such. At any rate in May 1960 he felt confident to set out on his own. He worked for just three months at Studio Five, receiving a regular weekly wage regardless of what work he did. Fashion photography had changed little since the war and the fresh, lively approach Bailey was trying soon brought him notice. In July 1960 he was offered a contract by John Parsons, Art Director of *Vogue,* and thereafter his progress was rapid. By 1961 he was photographing covers and major features for *Vogue,* and in 1962 started to work for the American, French and Italian editions of the magazine. He had become caught up in fashion photography, though not reluctantly, almost inevitably and only partly accidentally.

He was determined to somehow lead a glamorous life himself.

Soon after starting to work for *Vogue* Bailey began to take portraits for the magazine, as well as fashion. At this stage of his career he did relatively little of what is now called 'personal' work—photographs taken entirely on his own motivation. Certainly few such pictures were published at the time; but, on examining his files of past negatives for the 1983 retrospective exhibition at the Victoria and Albert Museum in London, Bailey discovered an extant set of photographs taken in early 1962 and documenting the townscape of the East End of London. The absence of people from most of this series and the dark, sombre tonality of the prints not only were highly unusual in his photography of that time, but also intriguingly anticipated the group of photographs published as *NW1* some twenty years later.

During 1962 Bailey gradually developed his fashion photography—in the studio at least—in a simplified, elegantly lit and posed manner reminiscent of the highly influential Americans Irving Penn and Richard Avedon. For a short period in 1961–2 his outdoor location fashion photography had taken on a new direction which reflected Bailey's response to first using a 35mm camera. He took several shots which cleverly exploited the flexibility afforded by the smaller format: he photographed on the streets, in everyday situations and made fashion photographs in the manner of a reportage photographer, reflecting the frenetic, urgent pace of modern life. The most famous feature in this style was shot in New York in January 1962 and was published in the US and British editions of *Vogue*. William Klein was the only other photographer who had explored a reportage-like approach to fashion, but despite the success of Bailey's pictures he soon dropped the idea.

Penn and Avedon were the two who above all set the standards for most fashion photographers in the early sixties. Their economical but powerful styles had the sort of graphic strength which made for maximum impact on the magazine page. Bailey's own photographs derived much from them—though he was never a mere imitator. He did not share their inclination to treat a fashion photograph as one might a still-life—as a composition of abstract shapes and textures. He always treated the model in front of his lens as a woman first and foremost and only second as a photographic subject. So his photographs retained a human quality which those of his American mentors usually lacked. The warmth evident in Bailey's photographs, allied to his increasing professionalism and control over the formal elements of a picture, resulted in a body of work between 1962 and 1964 which ranks as some of the very best fashion photography.

From their second meeting in 1961, until 1964, Bailey and Jean Shrimpton had lived—and more often than not worked—together. At the end of 1963 Bailey was divorced from his first wife and everyone expected him and Shrimpton to marry. Instead, a few months later, their highly publicized romance ended. I believe Bailey became disenchanted with fashion at this point, and it wasn't until 1970 that his original enthusiasm for this branch of photography returned.

One important outcome of the break with Jean Shrimpton was that Bailey became increasingly interested in portraiture. He was by now 'Swinging London's' most famous photographer. Many of the leading figures on the London scene were his personal friends—pop stars such as the Rolling Stones and The Beatles, fashion designers such as Mary Quant.

At the end of 1964 Bailey decided to chronicle some of this circle of friends and acquaintances in a publication entitled *David Bailey's Box of pin-ups*. Published in 1965, it was a series of 37 large photographs, each on a single sheet and packaged in a box—the idea being that you could simply discard any of the photographs

Bailey always treated the model in front of his lens as, first and foremost, a woman.

you did not wish to keep. No particular statement was intended in the choice of people included in the box; the only link was that all of his sitters were successful in their chosen field. The fact that the notorious gangsters the Kray Brothers were to be found side-by-side with Lord Snowdon, a member of the Royal family, caused considerable criticism. In a way one could deduce that Bailey was making an implied comment on contemporary so-called classlessness by his selection. Certainly there was a uniformity of approach in the photographs, where all the subjects were uncompromisingly shot close-to against a stark white studio backdrop. The *Box of pin-ups* helped to establish Bailey as a noteworthy portrait photographer, and, if some critics felt the range of his sitters to be too limited, at least everyone realized that he was more than just a fashion photographer. His reputation in this respect was further consolidated by the publication in 1969 of his valedictory tribute to the sixties: *Goodbye Baby and Amen.*

A much more extensive collection of portraits than *Pin-ups, Goodbye Baby* was also more widely varied in terms of photographic techniques. There were on the one hand extreme close-ups of heads, some distinctly unflattering, while at the other extreme he included highly romantic soft-focus glamour shots of stars such as Racquel Welch. Julie Christie and Diana Vreeland were photographed through a textured screen of theatrical gauze, which gave a rather painterly effect. But, as in *Pin-ups,* men predominated, and though Bailey has rarely photographed male fashion he usually prefers to make portraits of men.

The French actress Catherine Deneuve featured in *Goodbye Baby and Amen,* though by the time the book was published she and Bailey were on the point of divorce. They had married in London in the summer of 1965 amid incredible reaction from the media. Mick Jagger was Bailey's best man and the casual dress of Bailey and his bride had—surprisingly as it may seem now—caused a sensation.

After the wedding, their different careers prevented Bailey and Deneuve from seeing much of each other, and though they remained friends they had all but drifted apart by 1967. It was then that Bailey met Penelope Tree—a young American model and daughter of a millionaire banker. She became his constant companion and favourite model until 1973. If Jean Shrimpton had epitomized the first half of the sixties then Penelope Tree had just the sort of looks which Bailey felt suited the latter part of the decade. Fashion itself was changing to take account of the 'Hippie' movement. Hem-lines became longer again, clothes softer, more romantic, and the ethnic look first came into vogue. Penelope Tree's striking appearance suggested origins in another planet—the perfect place to have come from at the time. Despite this, Bailey's fashion photographs only occasionally showed the conviction of his earlier work. Largely through Penelope Tree's influence he became a fringe member of the drug culture himself, but although he grew his hair long and he was authentic enough to judge by outward appearances he was not really at ease with these times.

The hippie culture was far removed from the view of London espoused in Michelangelo Antonioni's 1967 film *Blow-Up.* Antonioni's portrayal of the photographer Thomas in *Blow-Up* has generally been supposed to be based on the lifestyle of David Bailey. Indirectly this is partially true. Francis Wyndham, who was a close friend of Bailey at the time, was engaged by Antonioni to produce a 200-page document of background research for the film. In 1964 Wyndham had written a lengthy piece for the *Sunday Times* which was based on interviews with not only Bailey but also his professional colleagues Terence Donovan and Brian Duffy. He had much unused material left over from the article and expanded this

Antonioni's film Blow-Up *has generally been supposed to be based on the life-style of David Bailey.*

into the document he produced for Antonioni. While the film thus contains many accurately observed details in relation to the business of fashion photography it should however not be understood as an accurate reflection of the working methods of David Bailey. Which of course it was. The result is that Bailey has been categorized in some quarters as being as insubstantial and superficial as Antonioni's photographer-hero.

Bailey himself had gone into film direction in 1966. He had been directing short commercials for some time and his early love of the cinema had ensured that the possibility of eventually making a film was never far from his thoughts. His first efforts resulted in a 30-minute piece entitled *G. G. Passion*. Roman Polanski helped finance the film, the plot of which centred on a fading pop star (played by the photographer Eric Swayne) who was hounded to death by his fans, a sort of latter day St Sebastian. Shot in both black and white and colour, the film had a limited release as a B-movie and enjoyed only a brief success. Visually quite promising, it failed primarily because the story-line simply did not sustain for half an hour. It was not until 1970 that Bailey made his next film, a television documentary about Cecil Beaton, which was first screened in 1971. Throughout his career Bailey has been involved in the early stages of many films which, for one reason or another, have failed to materialize. His only other substantial projects which were realized were hour-long television documentaries on film director Luchino Visconti and the American artist Andy Warhol. The Warhol film caused a furore when several self-appointed guardians of British morals attempted to have it banned because of some supposedly indecent passages it contained. The resulting publicity ensured an enormous audience when the film eventually was shown, most of whom were somewhat baffled by the dead-pan artist and Bailey's non-assertive, low-profile approach. The film did in fact succeed in painting a remarkably accurate and objective picture of Warhol, but has remained Bailey's last full-scale work for television. Filming always represented a viable alternative whenever he was dissatisfied with stills, but now he has regained all of his commitment to photography it is doubtful if—commercials apart—Bailey will embark on any major film projects in the foreseeable future.

At the beginning of 1970 Bailey started to re-think seriously his approach to fashion photography. He travelled to Turkey to shoot two major features for British *Vogue*. Previously, the choice of photographs, and the layout of his pictures, had been left entirely to the discretion of the magazine's art editor. Now Bailey insisted on choosing himself which photographs would be printed in *Vogue*. Those not familiar with this branch of photography may be shocked to learn that fashion photographers are rarely allowed to edit their own pictures, but such is the general practice. The photographs he took in Turkey amply justify Bailey's stand. They combine elegant dramatic poses with stunning and varied background landscapes, from the stone steeples at Goreme in Central Anatolia and the Temple of Jupiter at Euromus to a hairdresser's in Istanbul. Despite the evident success of these photographs it is doubtful if Bailey's measure of control was welcomed at *Vogue*'s London offices, and it is probable that a tension in his relationship with the magazine set in then.

Beady Minces, published in 1973, was Bailey's first book for four years. The accent was no longer on portraits but on presenting as widely varied a potpourri of photographs as possible. Ironically, in showing that his interests were far more diverse than most people had realized, Bailey was now criticized for being too

continued on page 59

He has now regained all of his commitment to stills photography.

THE
PHOTOGRAPHS

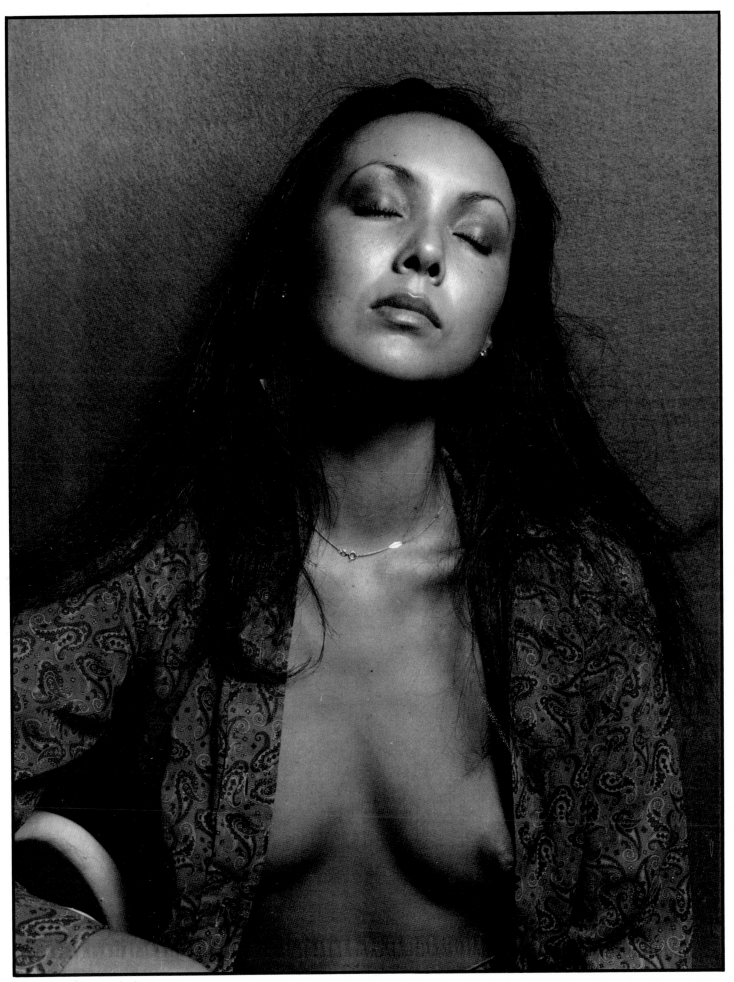

Marie, London, 1977

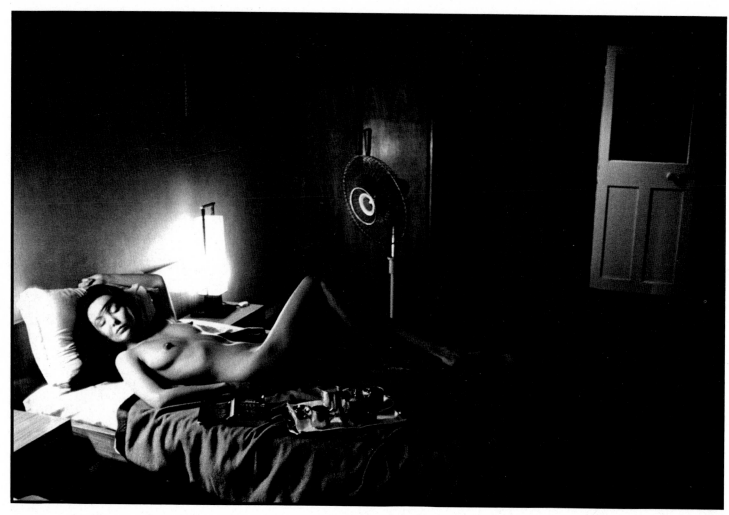

Marie, Southern India, 1978

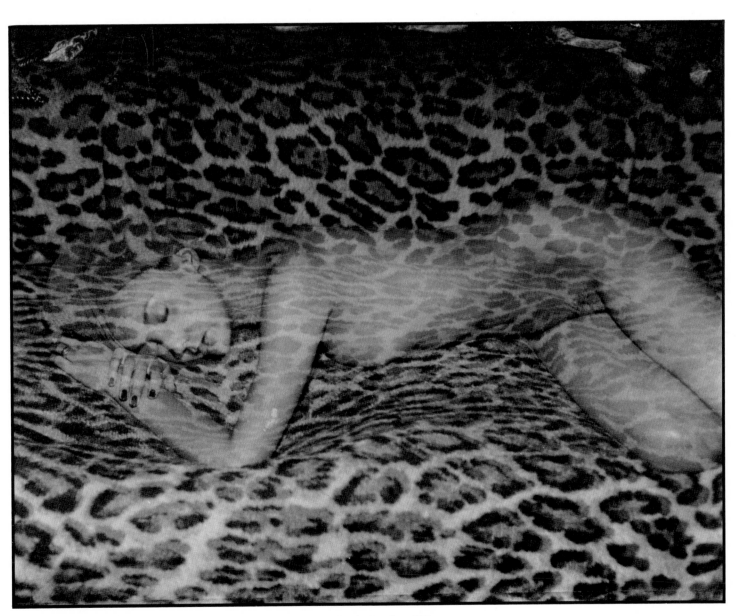

Marie, London, 1979

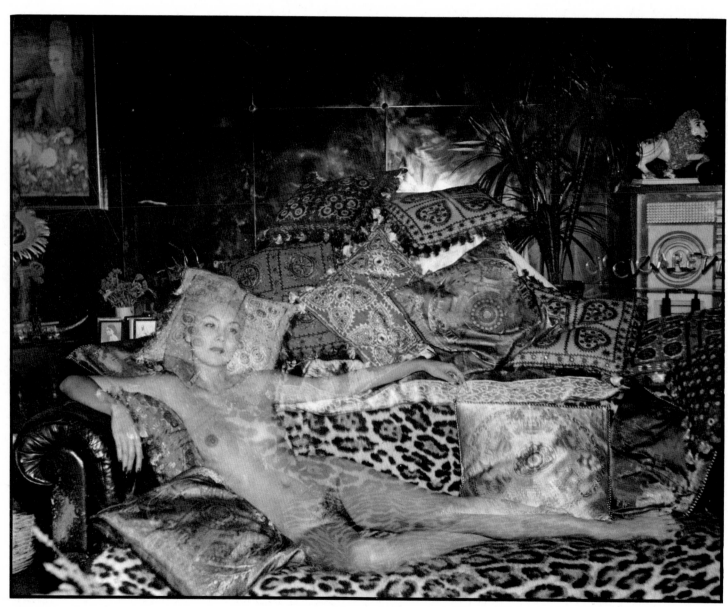

Marie, London, 1979

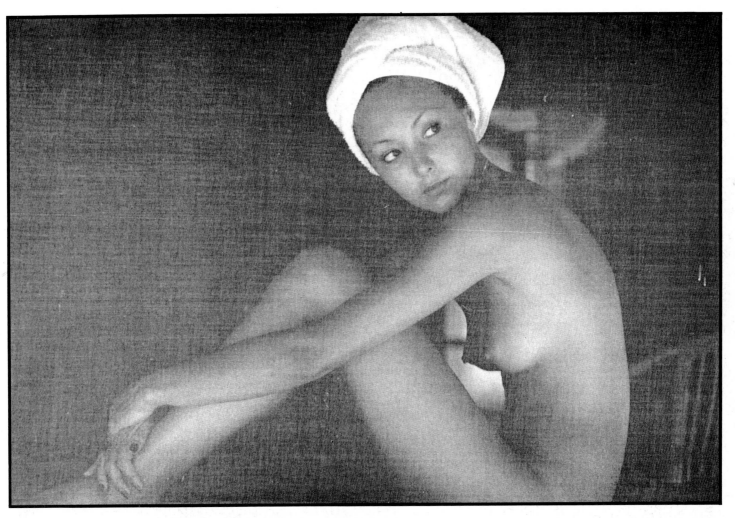

Marie, Tahiti, 1976

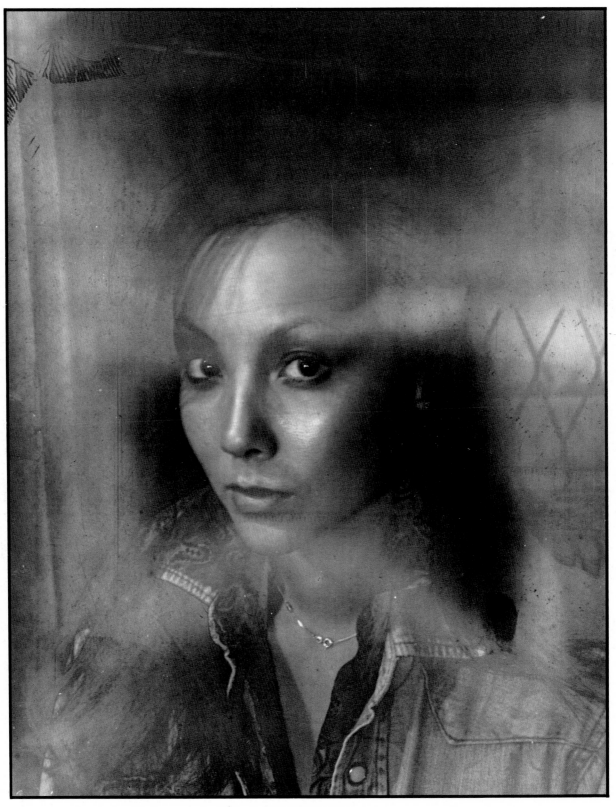

Marie, London, 1977

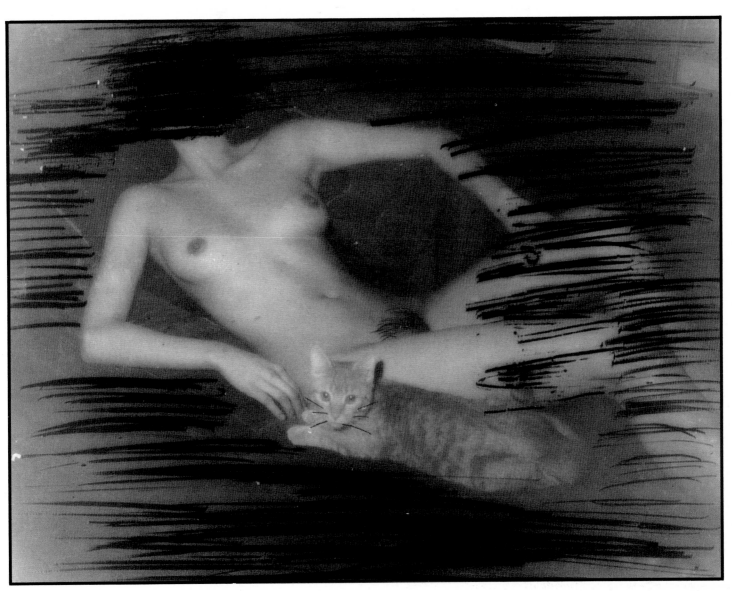

Marie, London, 1975

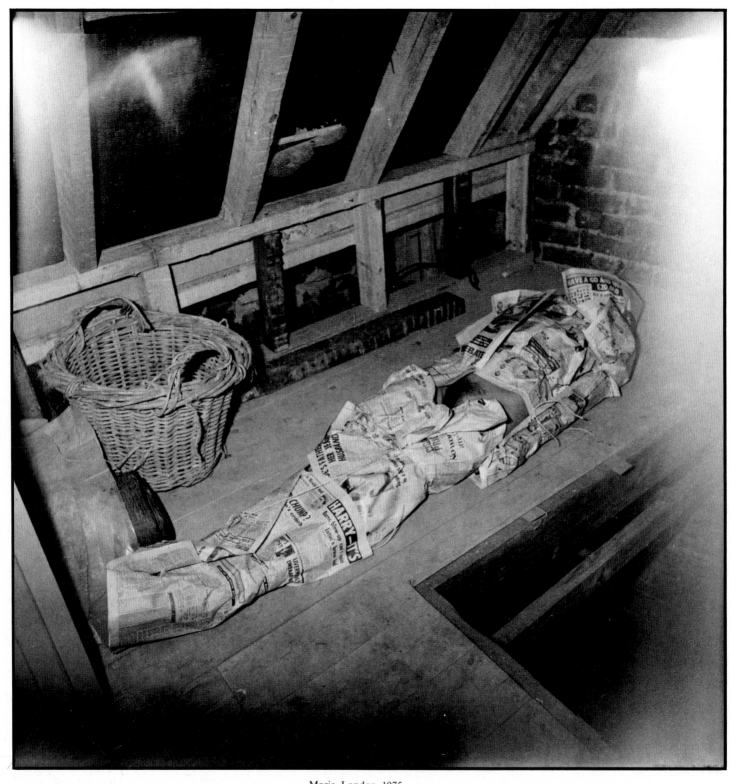

Marie, London, 1975

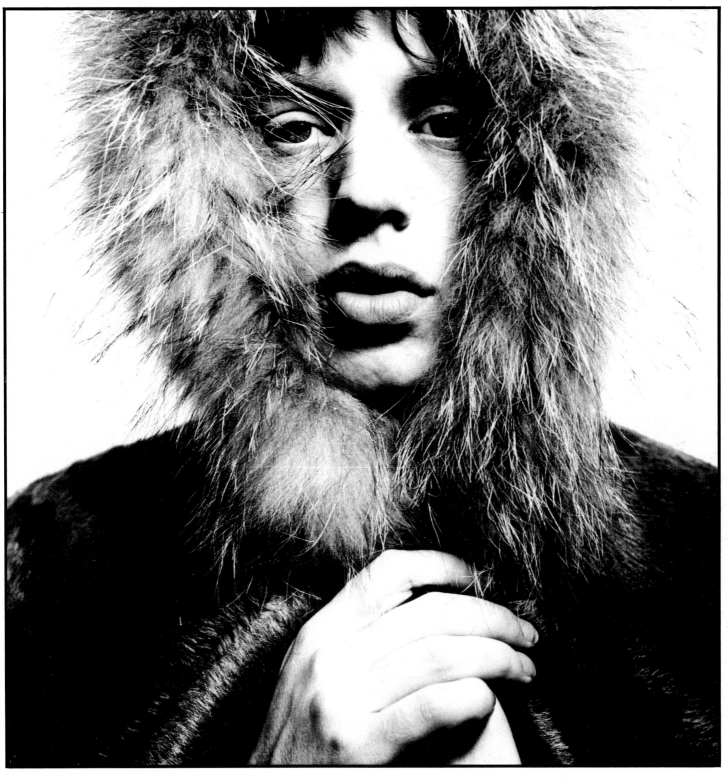

Mick Jagger, 1964

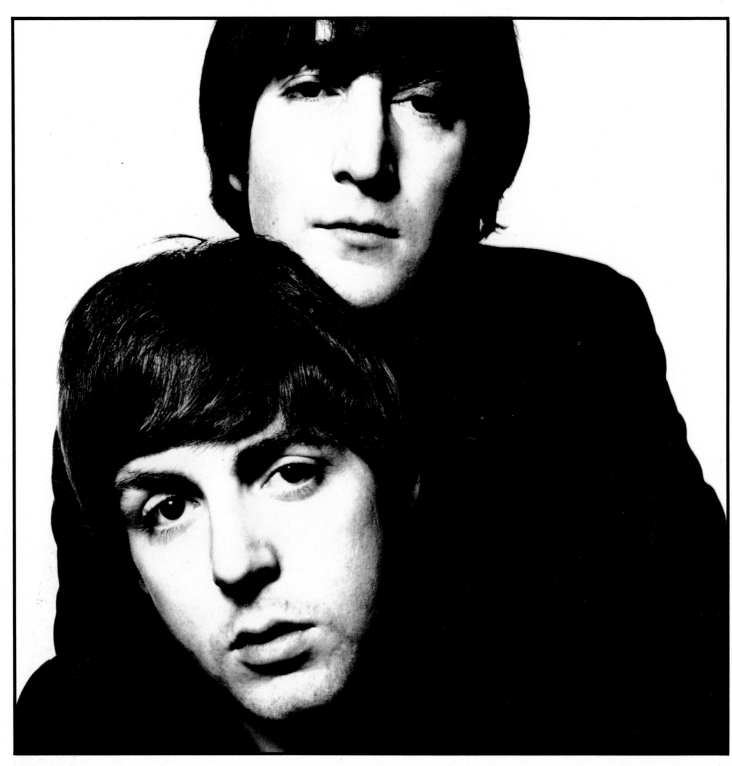

John Lennon and Paul McCartney, 1965

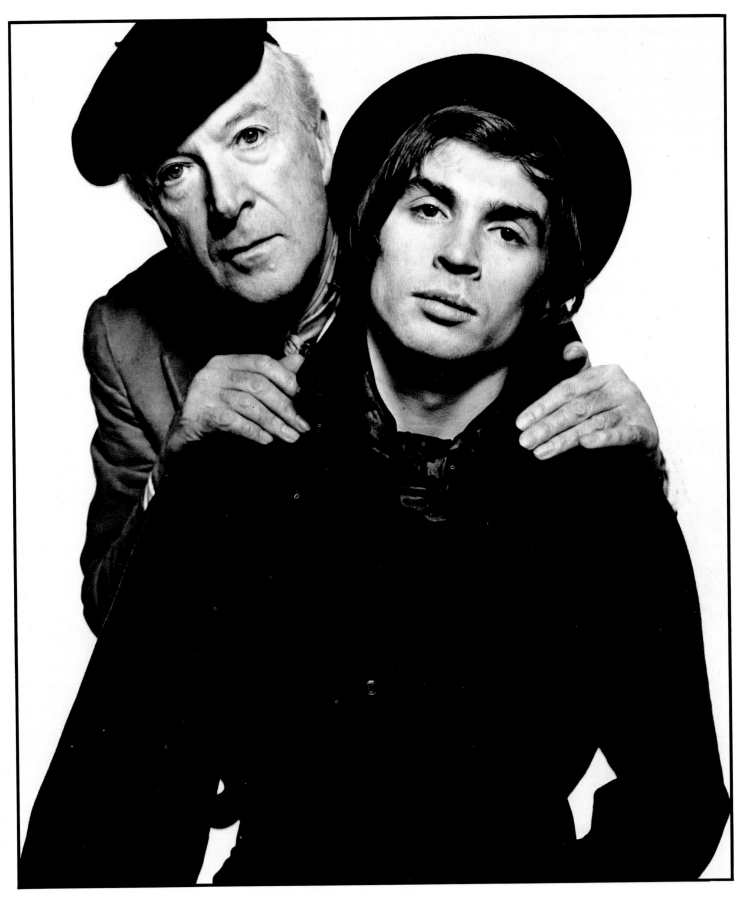

Cecil Beaton and Rudolf Nureyev, 1965

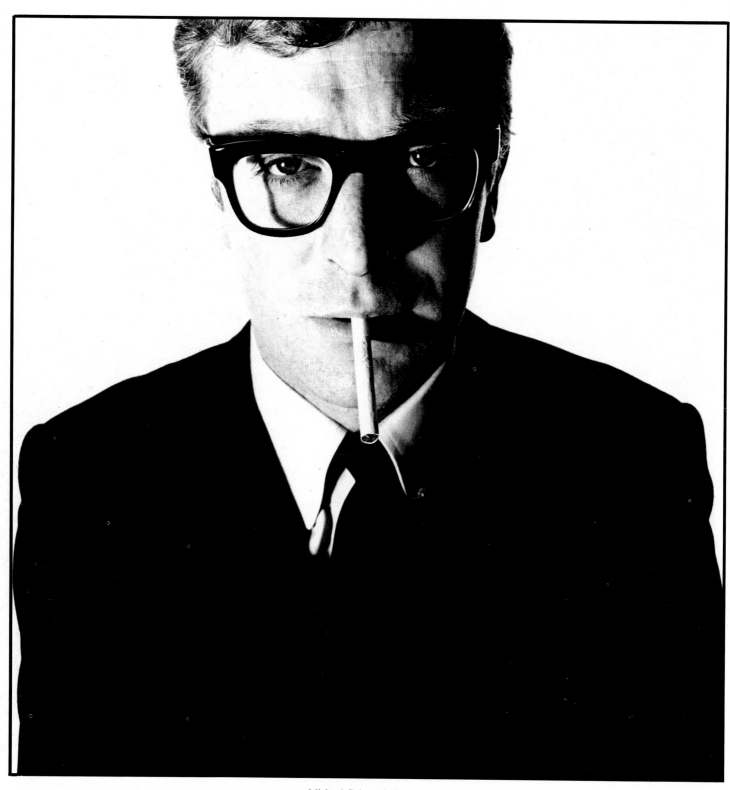

Michael Caine, 1965

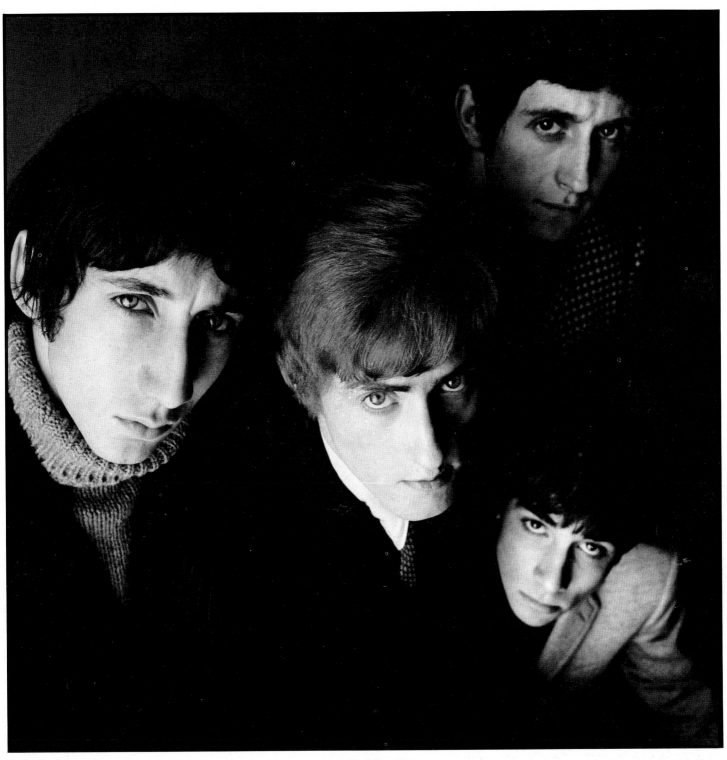

The Who, 1966

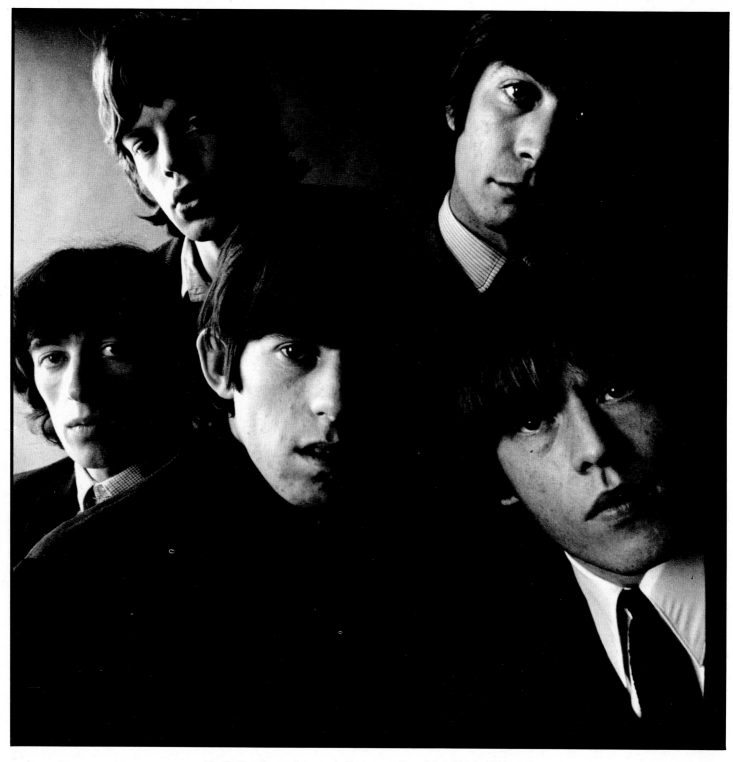

The Rolling Stones, for record album cover *Out of their Heads,* 1964

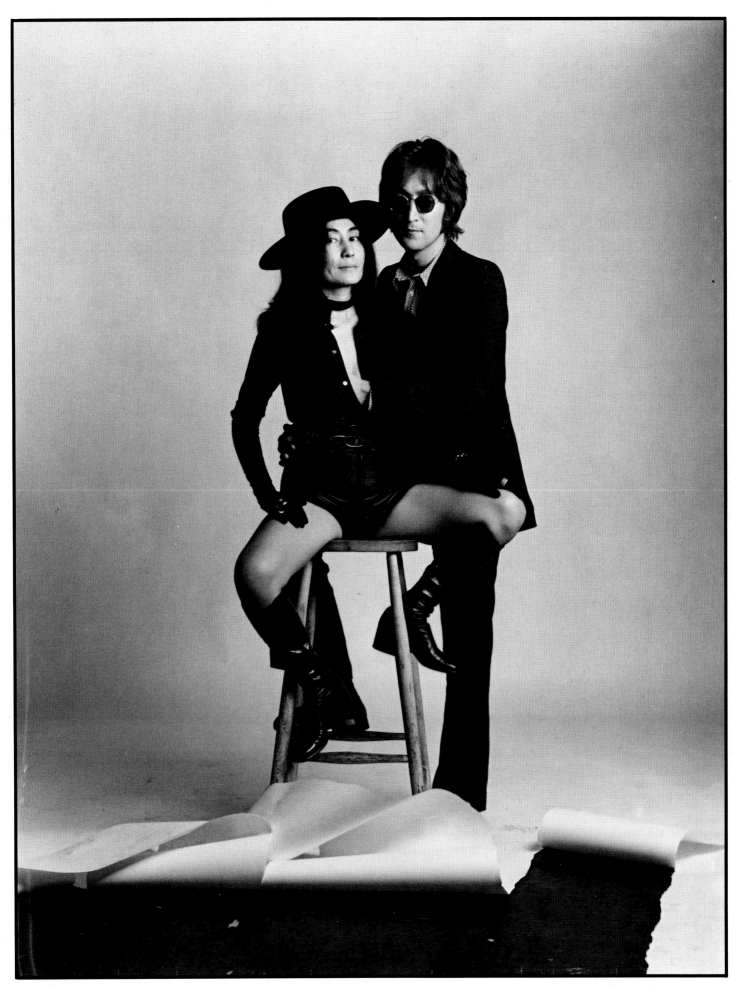

John Lennon and Yoko, 1974

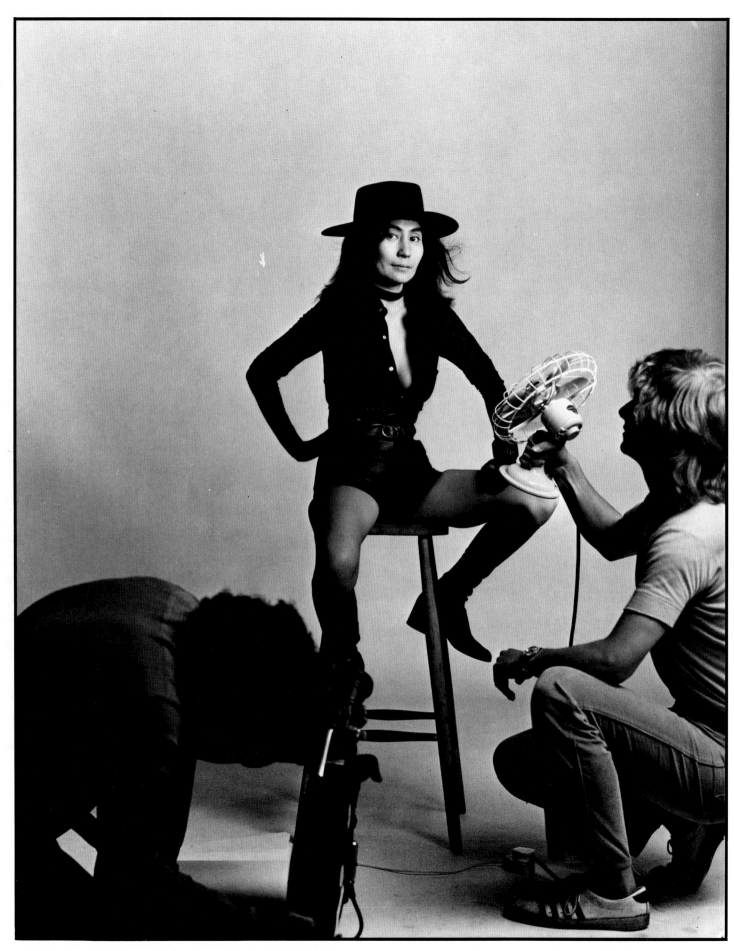

Yoko, 1974

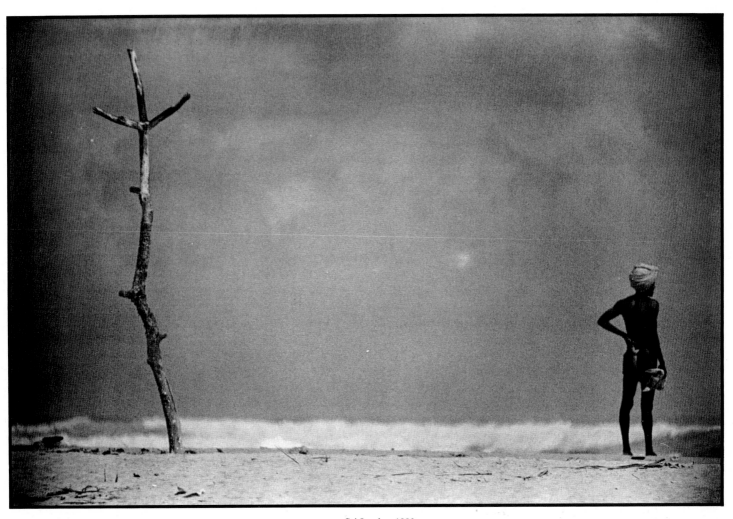

Sri Lanka, 1980

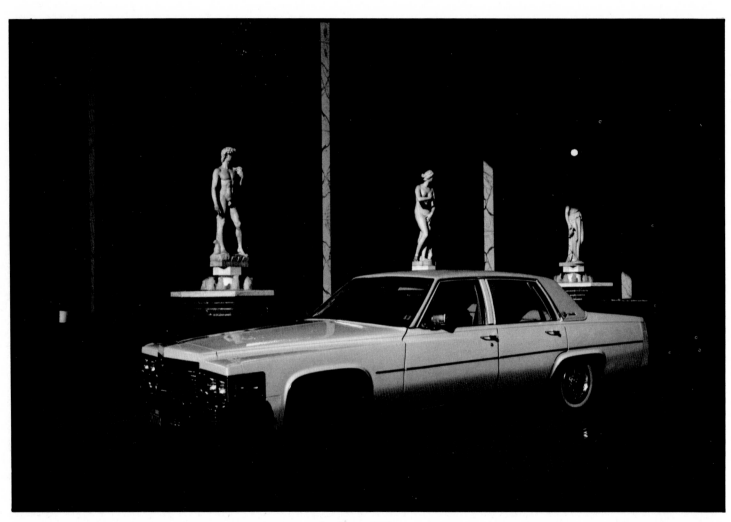

Las Vegas, 1982

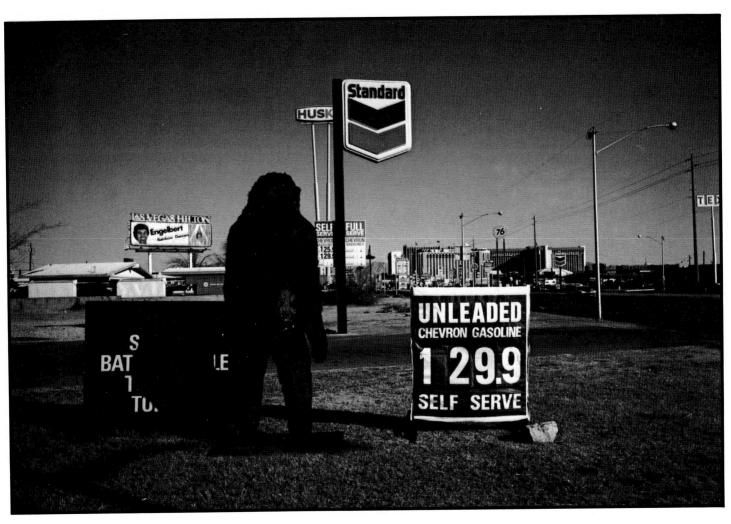

Las Vegas, 1982

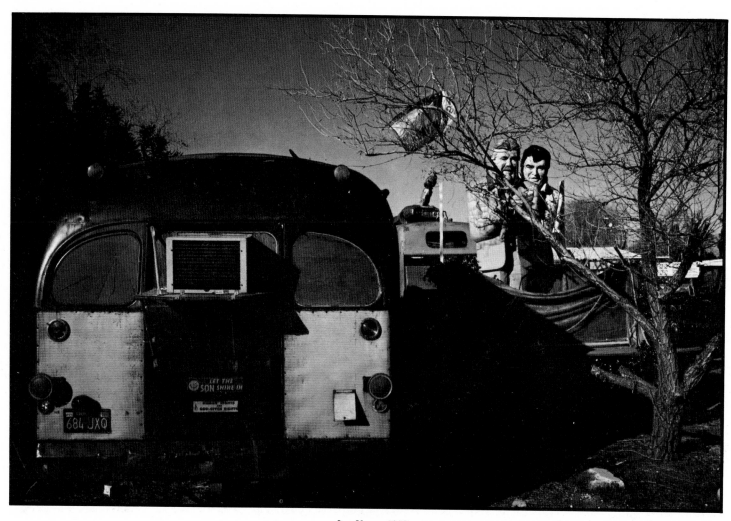

Las Vegas, 1982

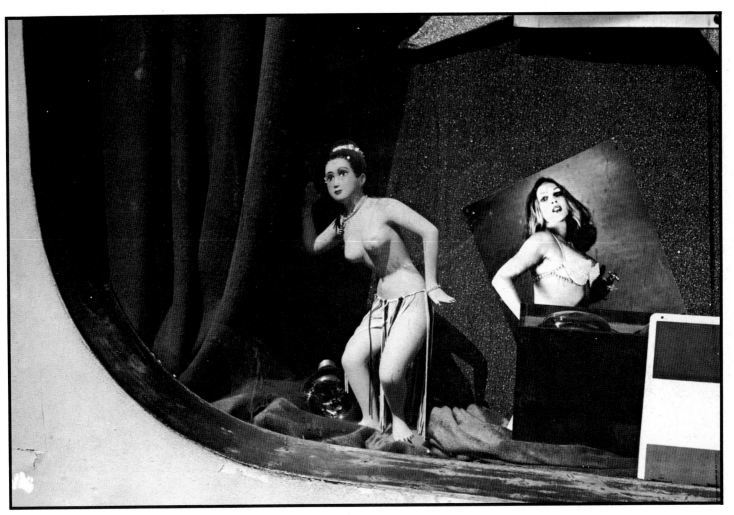

USA, 1982

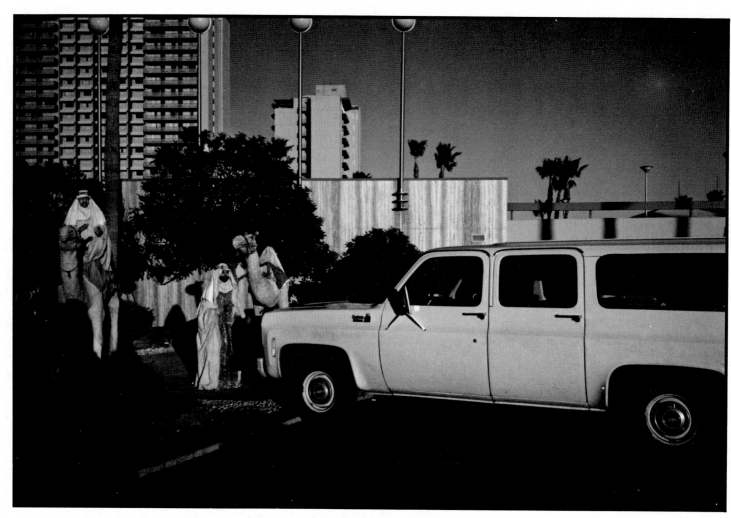

Las Vegas, 1982

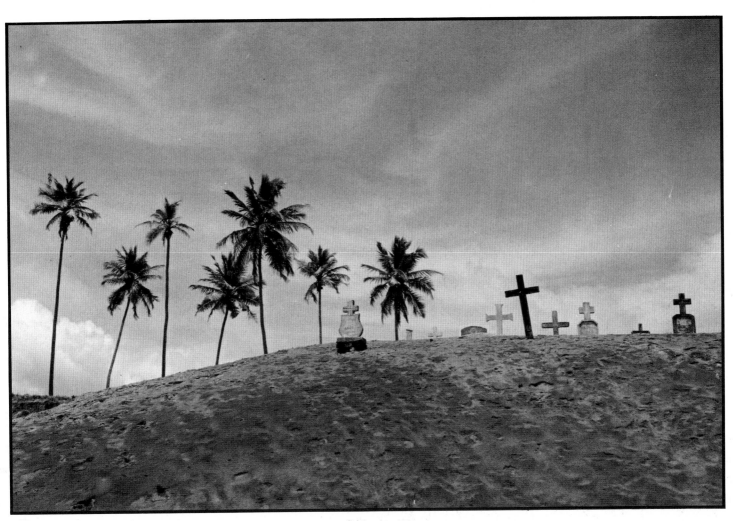

Sri Lanka, 1980

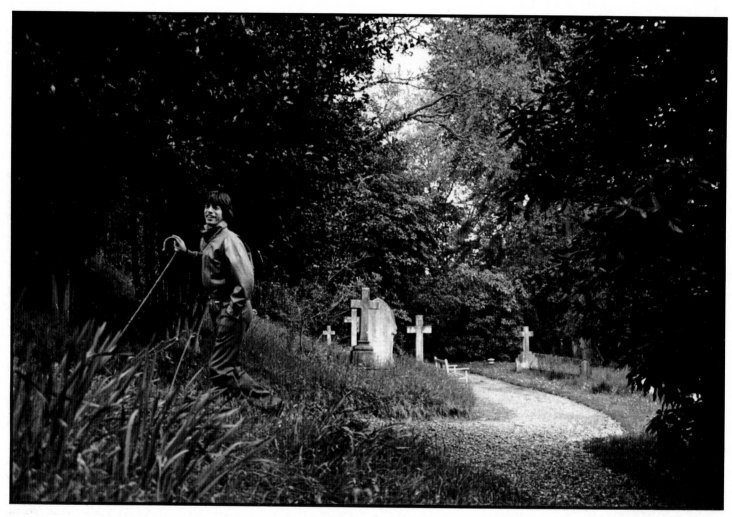

Mick Jagger, 1982

London, 1982

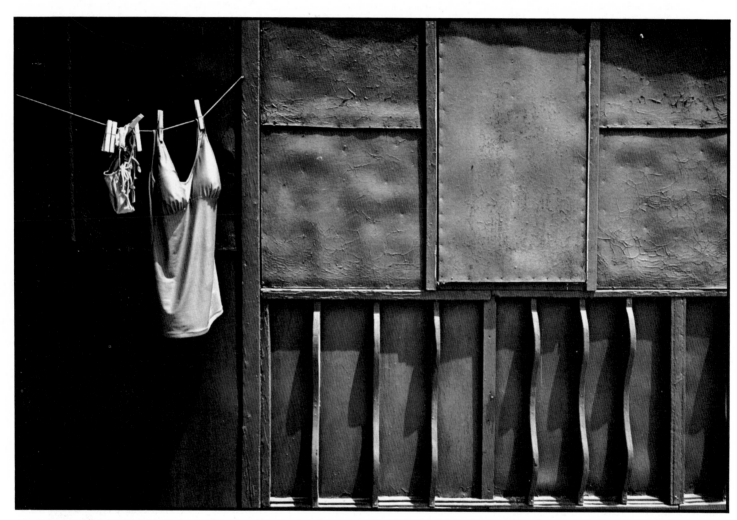

Sardinia, 1982

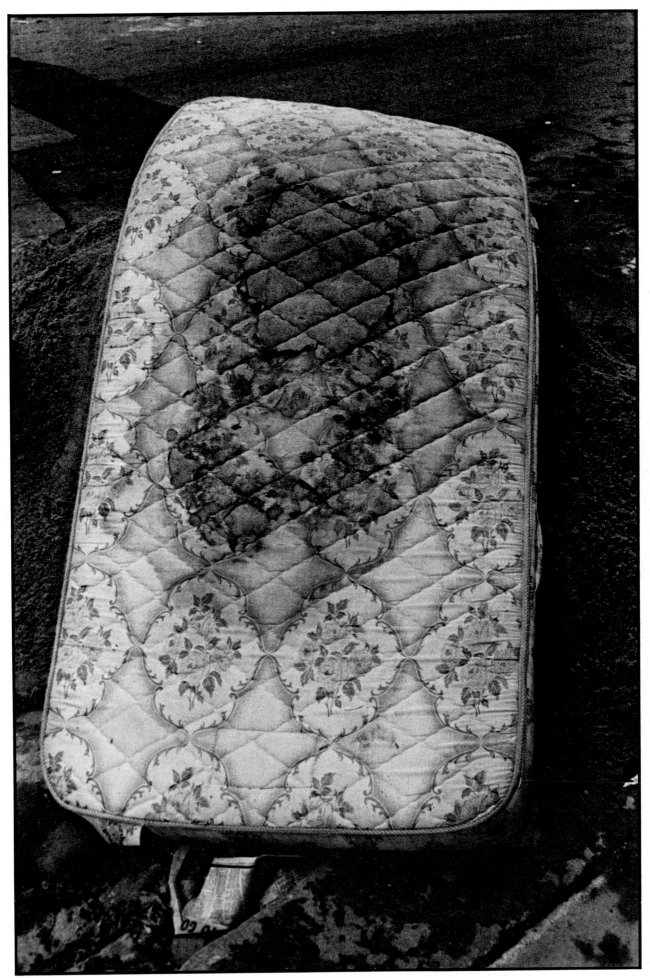

London, 1982

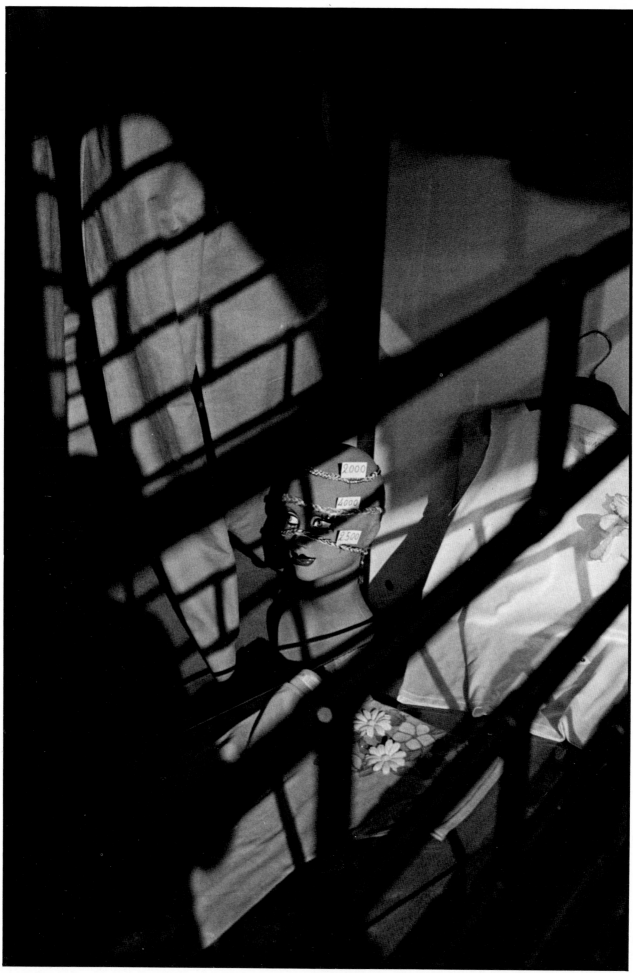

Milan, 1982

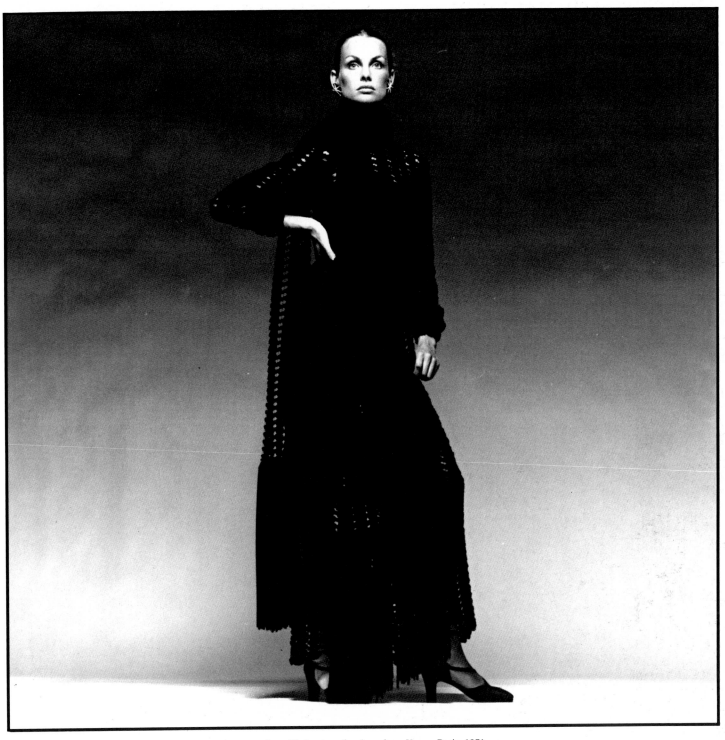

Jean Shrimpton, for American *Vogue*, Paris, 1971

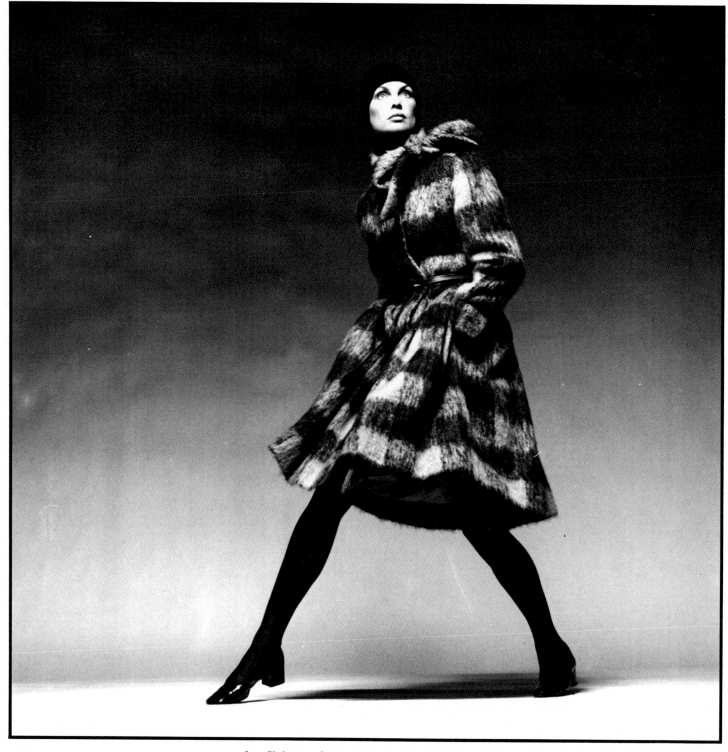

Jean Shrimpton, for American *Vogue,* Paris, 1971

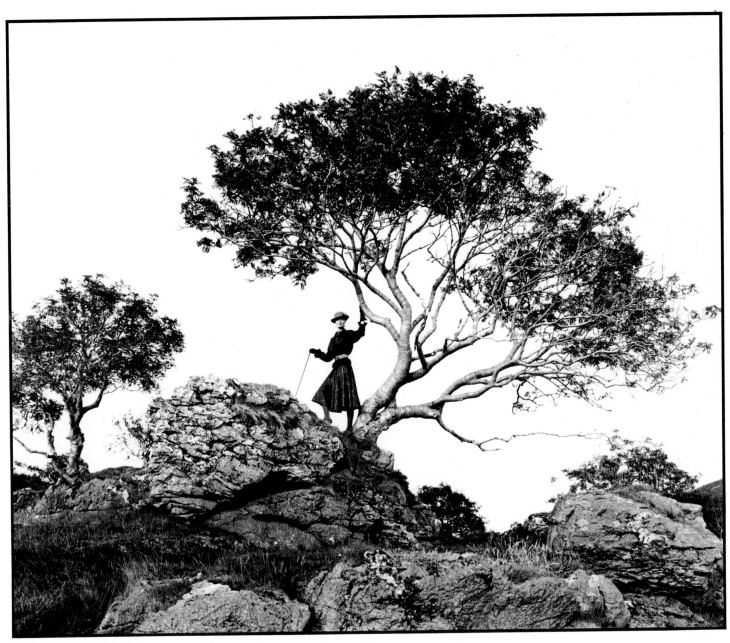

Catherine Dyer, for Italian *Vogue*, Isle of Skye, 1982

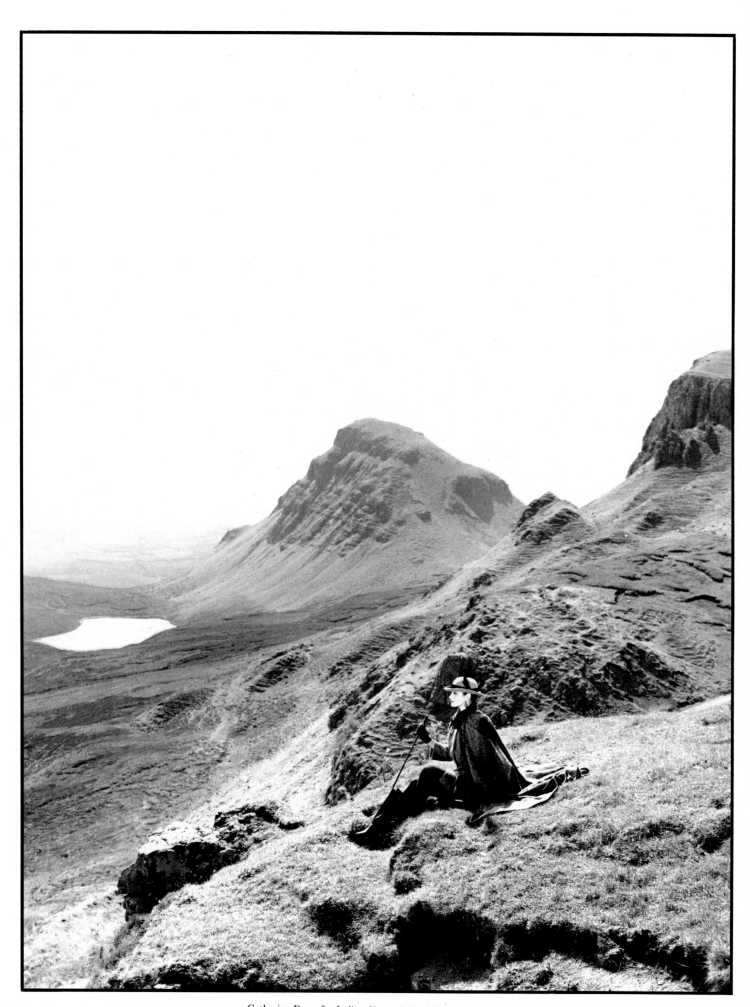

Catherine Dyer, for Italian *Vogue*, Isle of Skye, 1982

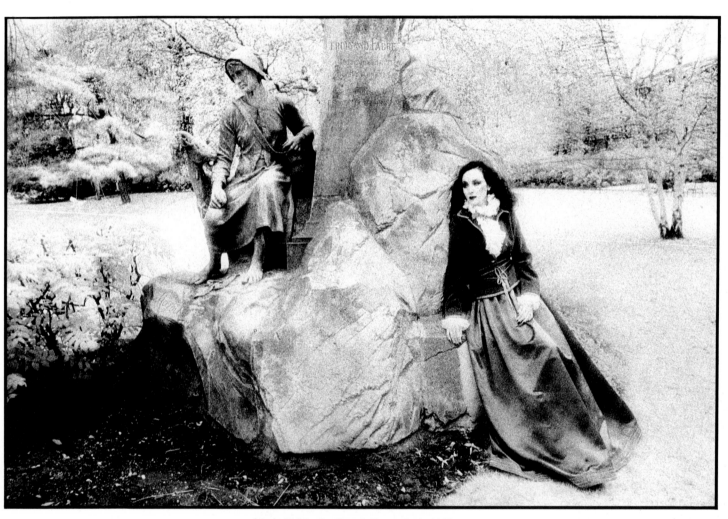

Maria Helvin, for French *Vogue*, Paris, 1977

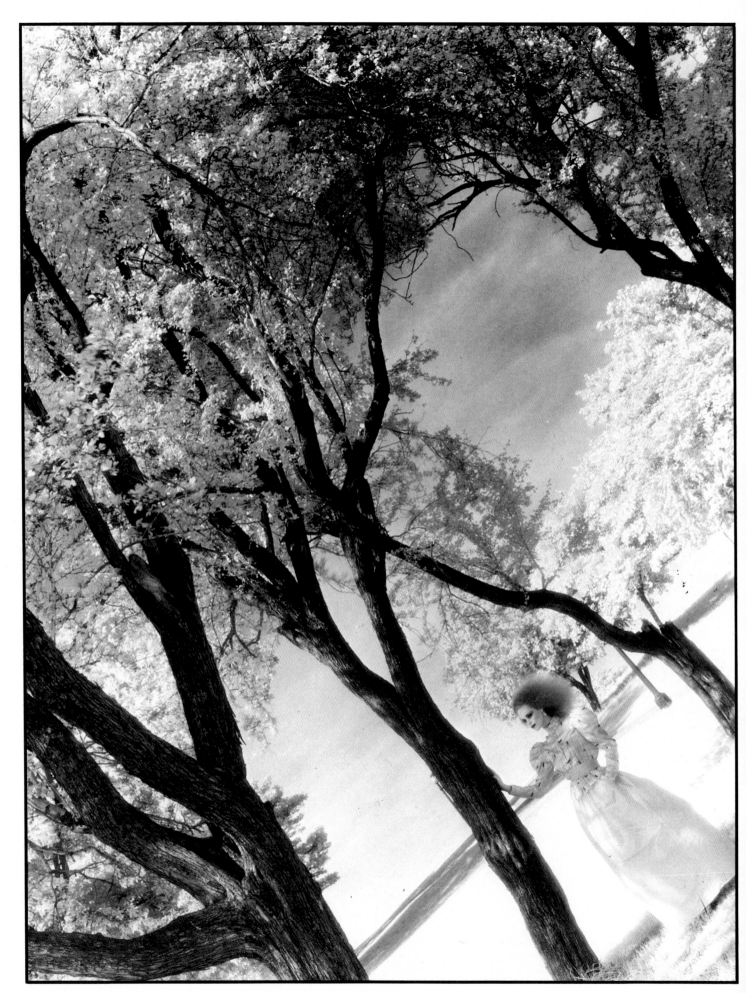

Kim Harris, for *Ritz*, London, 1980

44

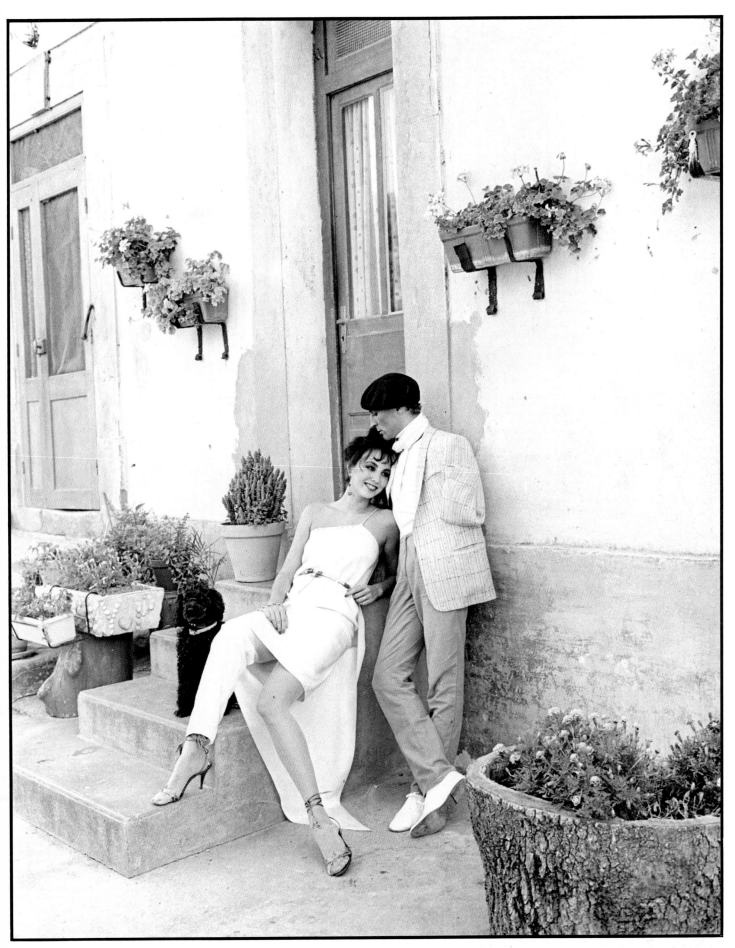

Marie Helvin and Regis, for Italian *Vogue,* The' Midi, France, 1981

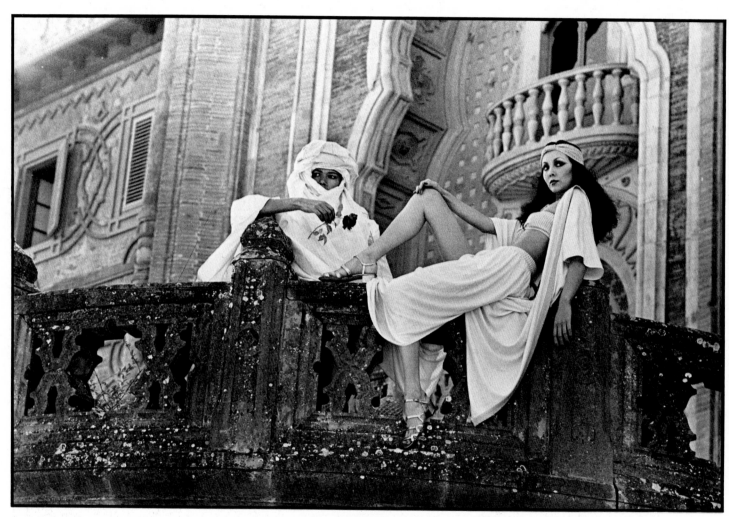

Marie Helvin and Michael Roberts, for Italian *Vogue*, Italy, 1975

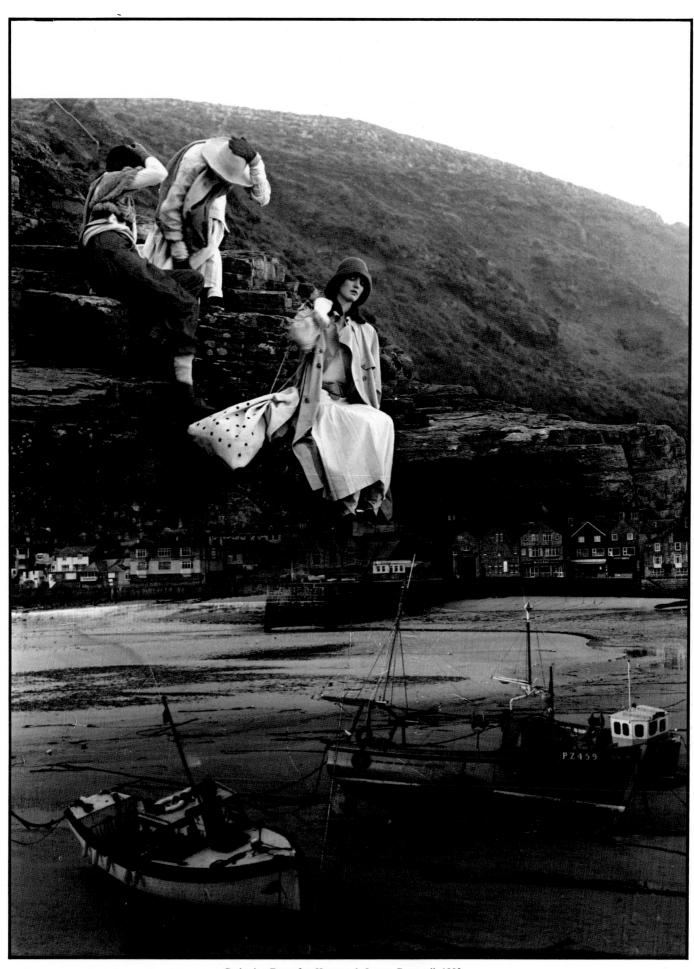

Catherine Dyer, for *Harpers & Queen,* Cornwall, 1982

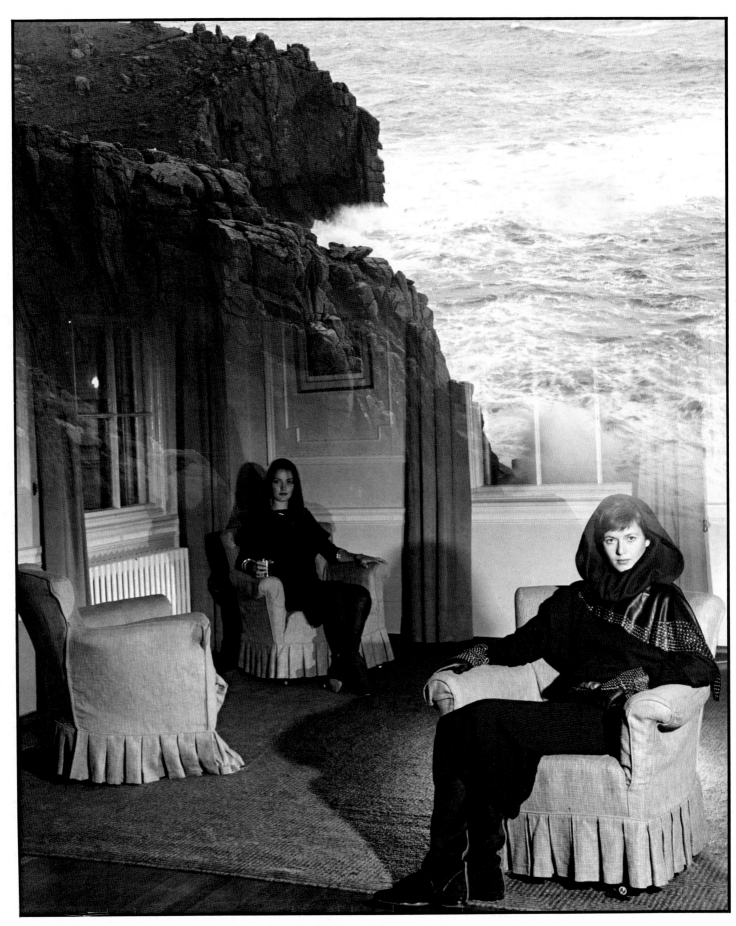

Catherine Dyer, for *Harpers & Queen,* Cornwall, 1982

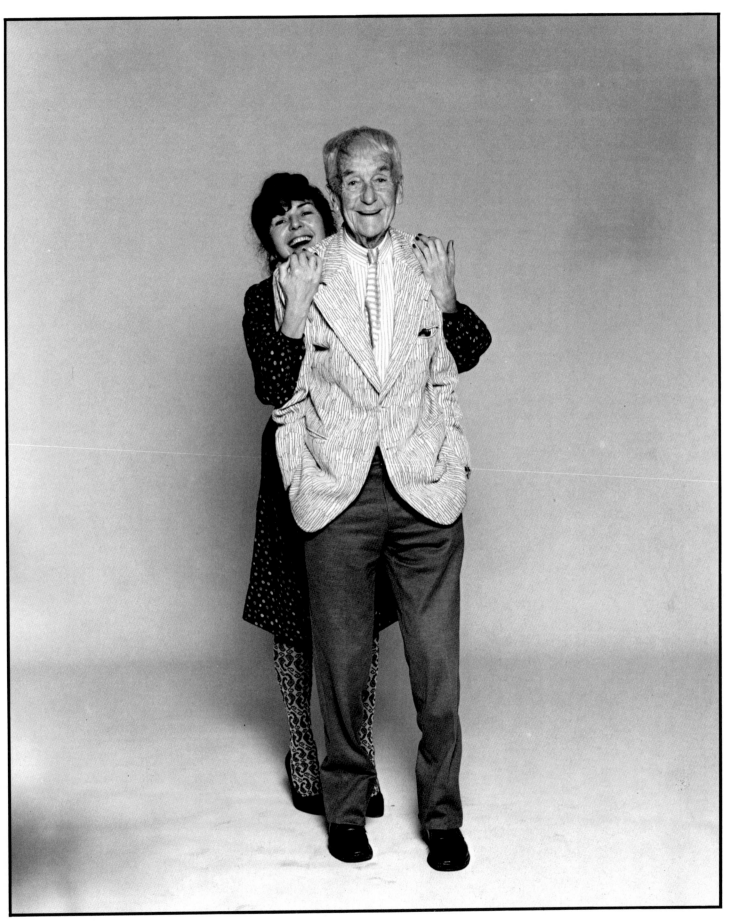

Florette and Jacques Lartigue, 1982

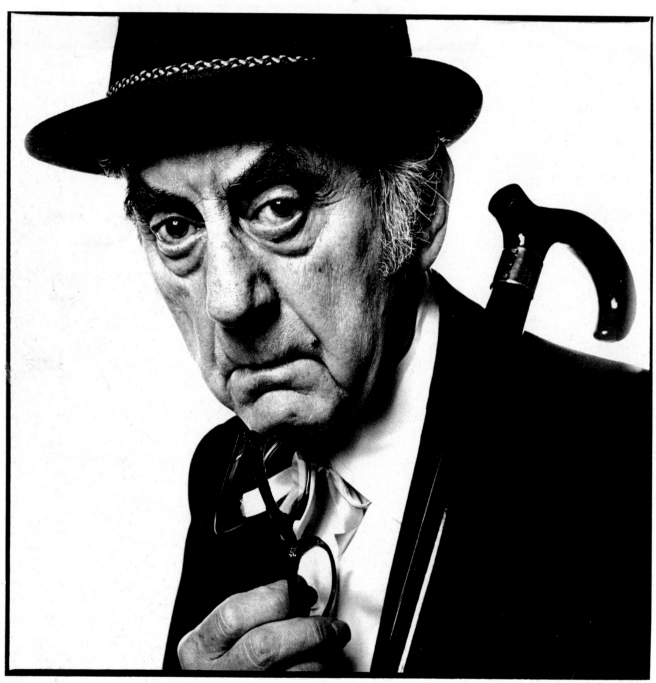

Man Ray, London, 1968

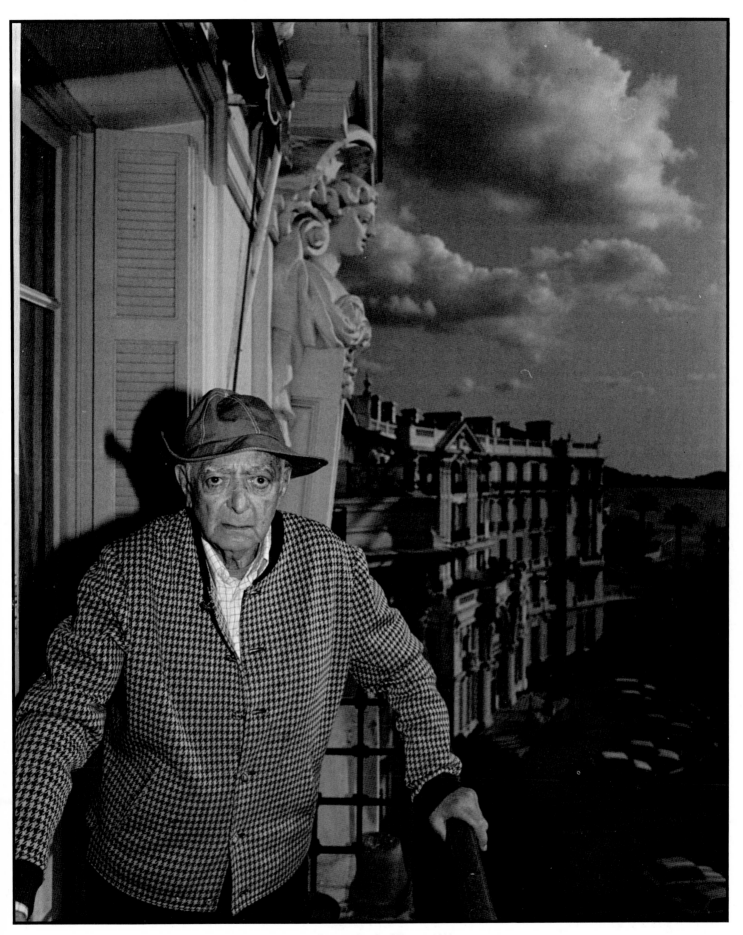

Brassaï, South of France, 1983

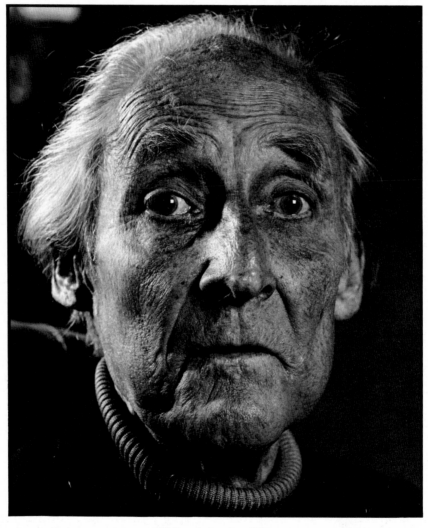

Bill Brandt, London, 1982

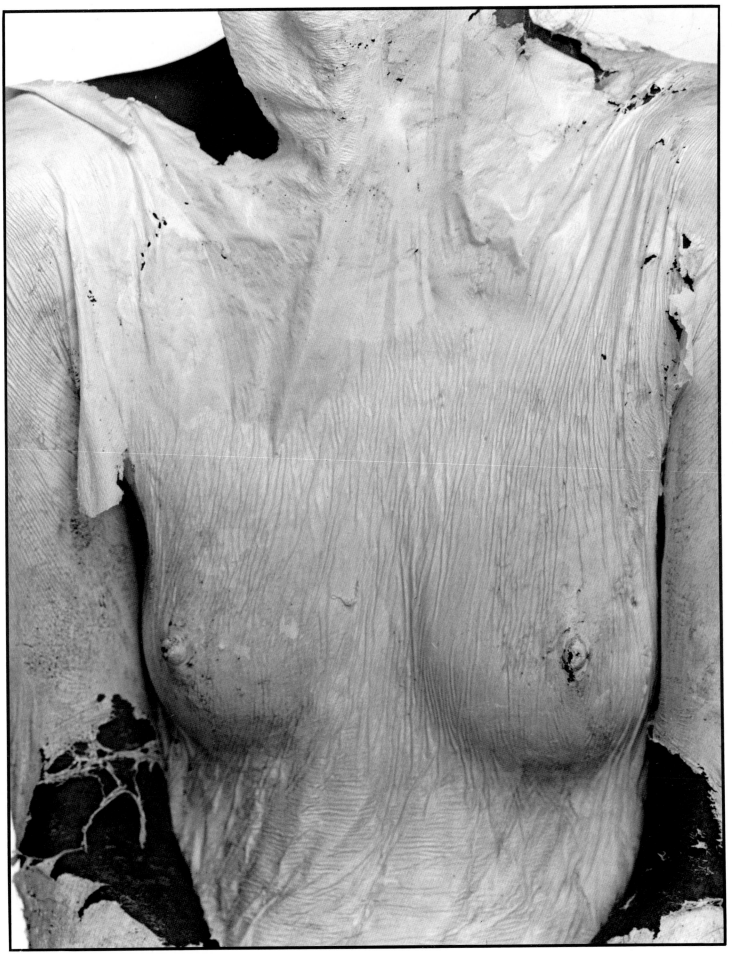

Nude, London, 1982

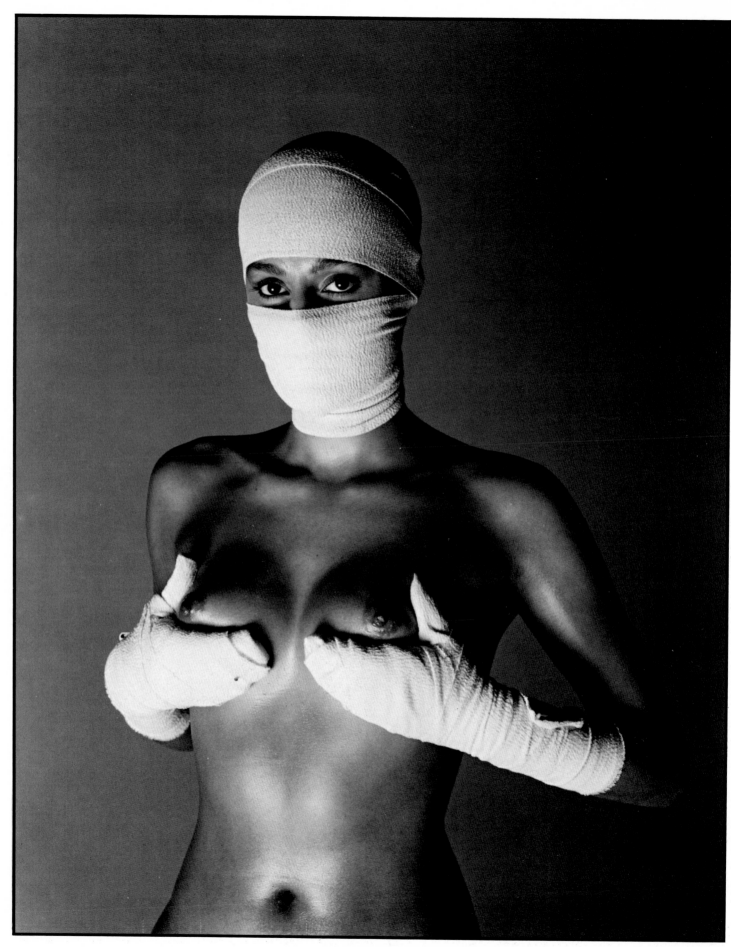

Nude, London, 1981

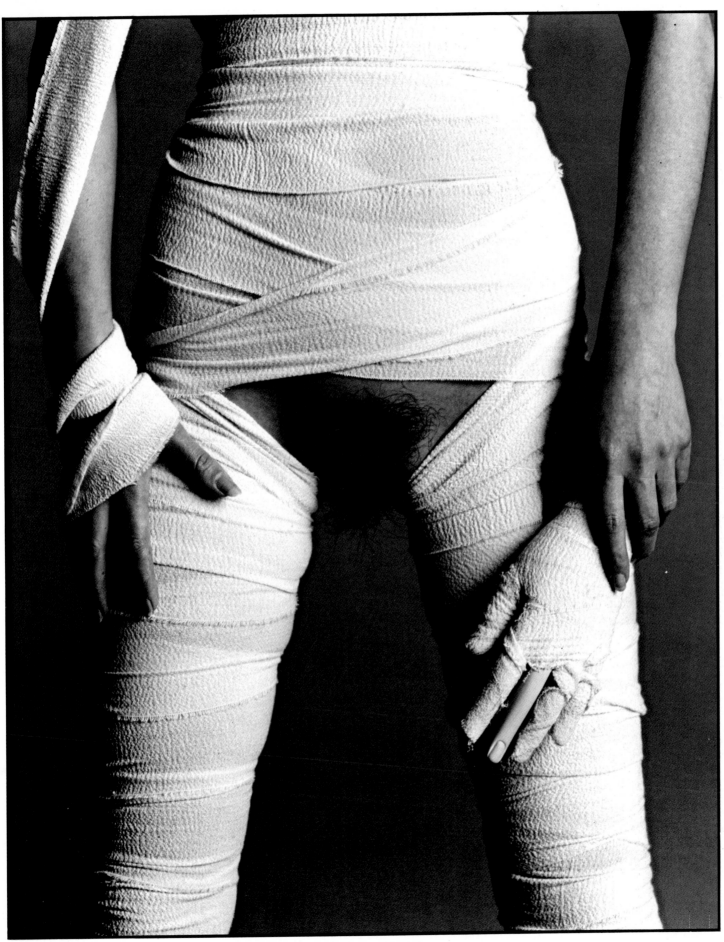

Nude, London, 1981

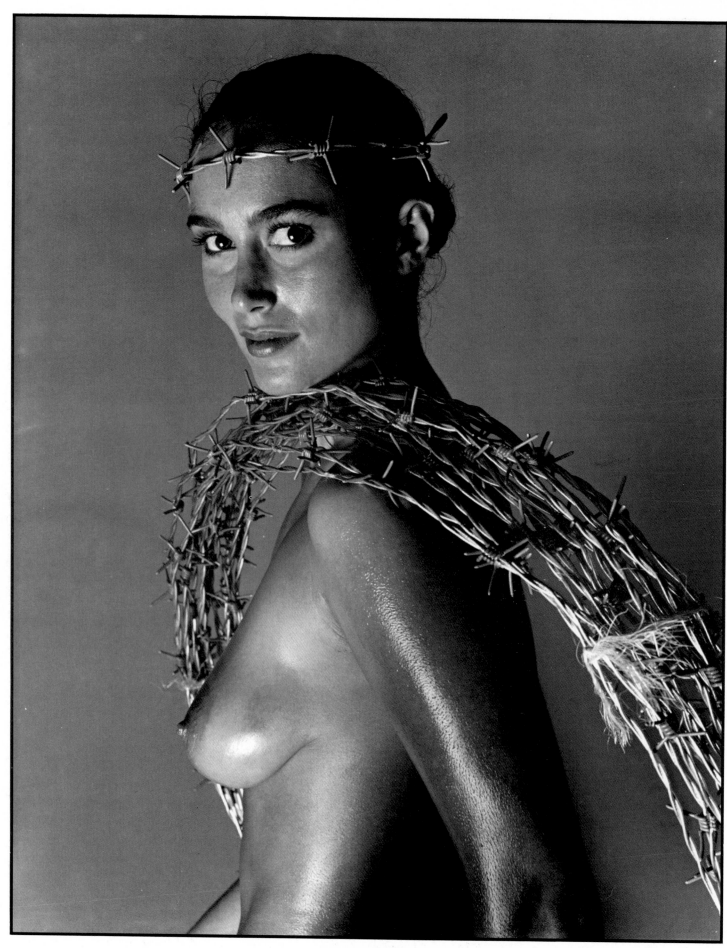

Nude, London, 1981

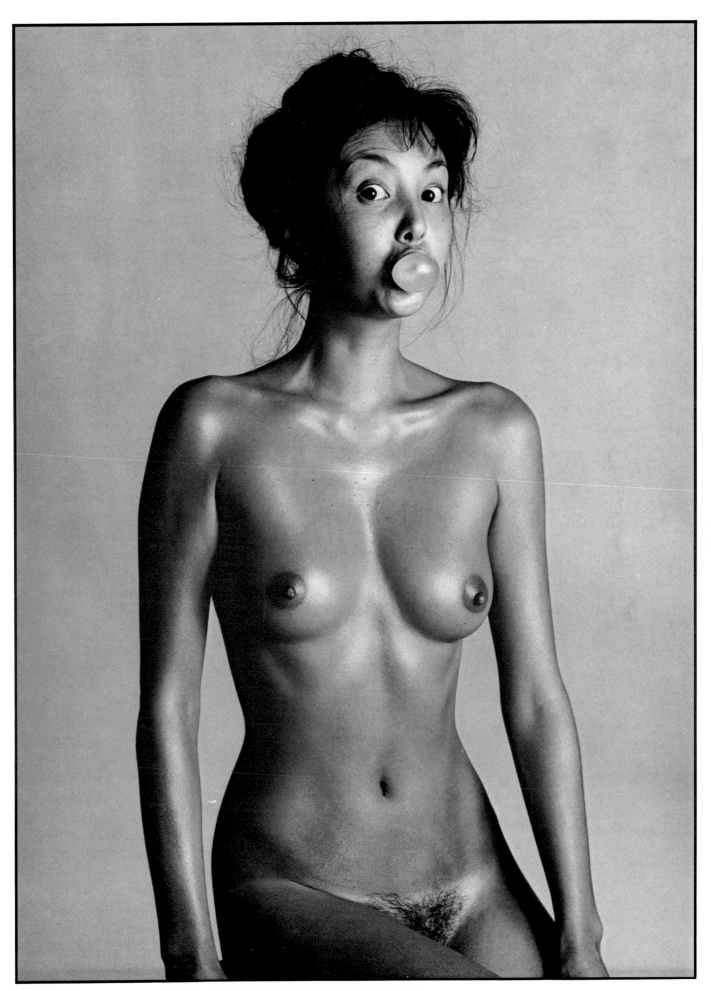

Marie Helvin, London, 1979

57

continued from page 8
broad, too eclectic. He is by nature an eclectic, and in some way *Beady Minces* is a very accurate reflection of Bailey's wide-ranging photographic interests. More than half of the photographs reproduced in *Beady Minces* were 'personal' pictures, 35mm reportage or snapshots taken in countries all over the world. Combined with these were numerous other categories of work. He included several nude studies and fourteen portraits. The illustrations spanned sixteen years (two landscapes dated from the RAF years) and one of the portraits, of Somerset Maugham taken in 1960, was the first Bailey had ever had published. Particularly effective were the portraits of architect Philip Johnson (1969), Salvador Dali (1971) and the fashion designer Erte (1973). The problem for most critics probably lay in the reportage pictures. These were clearly often taken very light-heartedly, just for fun, while others were obviously more carefully considered. By having both types mixed closely together the distinctions are blurred and both are misunderstood. While *Beady Minces* did indeed demonstrate Bailey's wider photographic interests, it probably failed in the last analysis to convince that he excelled in other than fashion or portraiture.

The 1970s ushered in some important changes in the photographic scene in Britain. Most significant was the growing acceptance of photography's elevated status within the arts, though in this respect Britain still lagged behind the USA. Nevertheless there were several crucial developments. In 1971 Roy Strong, then director of the National Portrait Gallery, instigated a series of photographic exhibitions, the first of which, *Snap,* featured the work of cartoonist Gerald Scarfe, painter David Hockney, with photographs by Bailey. This was the first time Bailey's photographs had been exhibited on the walls of a gallery. Shortly after this the Photographers' Gallery opened in London, the first solely photographic gallery in Britain, and here, at the beginning of 1973, Bailey had his first one-man exhibition *Bailey up till now.* The theoretically fickle and superficial photographer of the sixties had stayed the course and was still around in the seventies. He was made a Fellow of the Royal Photographic Society in 1972, a significant measure of his growing public acceptance considering the innate conservatism of the RPS. His work began to appear in photographic magazines, though not yet *Creative Camera,* the most purist of the British journals.

As if to allay criticisms that *Beady Minces* was too diverse, Bailey's next book *Another Image: Papua New Guinea* dealt with just one remote tribe in Eastern New Guinea. The Papuans were as yet untouched by 'civilization' and to photograph them was, for Bailey, something of a pilgrimage, a realization of an ambition held since childhood. He said: 'I hope I have managed to capture a little more than just a social document; if I have it is an added bonus.' Most of the photographs were unposed, but there is a small group showing tribesmen isolated against white backgrounds redolent, though not in technique, of Irving Penn. The colour photographs were all taken on Polaroid SX-70, reflecting perhaps the speed at which the series was made. If Bailey had had more time at his disposal the book as a whole might have shown more of the penetration it sometimes appears to lack.

David Bailey enjoys being prolific. He is constantly taking photographs, whether commissioned to or not, and is equally eager to have as many as possible of the better ones published. The rise in demand for photographic books in the 1970s meant that Bailey was able to use this medium to publish many photographs for which there was no other obvious public outlet. Hard on the heels of *Another Image* came *Mixed Moments.* Appearing in 1976, *Mixed Moments* was co-published by

Bailey enjoys being prolific: he is constantly taking photographs.

59

Bailey and the British division of Olympus Cameras. Shortly before this Bailey had started to feature in Olympus's television advertisements, an unusual step for a photographer, but one that ensured his face was remembered by a very wide public. *Mixed Moments* reverted to a format similar to that of *Beady Minces*. There were 92 pages of reportage-type photographs taken mostly in India, Japan, Brazil and the Pacific. The next section comprised nineteen nude photographs of Marie Helvin, Bailey's third wife, whom he had married the previous year. All of these pictures were printed in sepia. The final sixteen pages were devoted to colour reproductions of fashion photographs shot between 1973 and 1976. In 1976 Bailey ceased, after sixteen years, to work for British *Vogue*. Since then the main vehicle for his best fashion work has been Italian *Vogue*, which has always allowed him the freedom he needs to produce his most effective work. A glance at the fashion photographs in *Mixed Moments* tells immediately how Bailey's style had changed since the 1960s. Compositionally the photographs are much more complex and, as with the series shot in Turkey in 1970, there is a much greater emphasis on the background context. Bailey commented in the introduction that he called the fashion pictures 'construction pictures' as opposed to the majority of the book which was 'seeing pictures'—'people, places and things that are in their own space and not rearranged by the eye'.

The flow of books was interrupted until 1980, when *Trouble & Strife* (published in the USA as *Mrs David Bailey*) appeared: a further collection of photographs of Marie Helvin which took up from where he had left off in the section of nude photographs in *Mixed Moments*. The break with British *Vogue* left Bailey free in 1976 to start up his own newspaper *Ritz*, which he co-produced with David Litchfield. Bailey and Litchfield had collaborated earlier in the 1970s on a short-lived magazine *Image*, for which Bailey acted as photographic consultant. *Ritz* was printed in a format similar to Andy Warhol's *Interview* paper, with similar contents ('fashion, style and gossip') though more strongly visually orientated. They did not expect it would run for more than a few issues, but it continues to thrive today, though Bailey has recently resigned his co-publishership. It provided a vehicle not only for some of Bailey's more risqué fashion and portraiture but also for several other photographers who had lost out to British *Vogue*'s increasingly American bias.

Although publicly Bailey was not much heard of towards the end of the seventies he was privately laying the foundations for several projects which are coming to fruition in the 1980s. He was still very busy as a commercial photographer, in which sphere he remained active not only in fashion and portraiture but also in the fields of beauty and advertising photography. His advertising work was not just restricted to fashion, either, for it encompassed products ranging from airlines to jewellery, from motor cars to record album covers. Even more significantly he started in this period to print his own photographs again. He had become an avid collector of photographs, particularly those of the 19th century masters such as W. H. Fox Talbot and Roger Fenton. Perhaps this encouraged him to take a renewed interest in photographic processes. The outcome was that he set up a fully archival darkroom beneath his London studio where he would print not only all of his more important bromide prints but also began to experiment with many of the older processes, such as gum-bichromate, uranium and copper-toning and printing-out paper.

In July 1979 Bailey contributed to a mixed exhibition which opened the new Olympus Gallery in London. For much of his life a vegetarian, he chose to show

four close-up colour photographs of severed heads of chickens and pigs, dripping blood. As if in reaction to the 'softness' of much of his better known work he was now confronting the viewer with photographs which were dramatically aggressive —to many almost repulsive. Clearly Bailey was revelling in the freedom of expression made possible by books and exhibitions of non-commissioned photographs.

Just nine months later, in February 1980, Bailey exhibited thirty photographs at the Olympus Gallery entitled *The Boat People*. In July 1979, while in Hong Kong, he had made an extended coverage of Vietnamese boat refugees. The photographs can be divided into two principal groups: seated figures in groups shot against a plain white back-drop and lit by hard, direct flash; and larger, unposed groups of frightened-looking refugees, equally poignant in their angular, claustrophobic way. They are perhaps Bailey's most successful reportage photographs to date and it is unfortunate they did not receive wider coverage.

Trouble & Strife was published at the end of 1980. It was conceptually a tighter project than Bailey's books of the 1970s in that it concentrated on one subject, but the extreme variation of techniques which he adopted leaves the book lacking in continuity. Despite this, few of the pictures can be counted as complete failures and some rank among the best of recent nude and glamour photography.

There could hardly be a greater contrast between *Trouble & Strife* and *David Bailey's NW1*, published in 1982. *NW1* is the postal district of London in which Bailey has lived since 1961. In 1980 he embarked on a project to record the urban landscape of his home district. Originally he had planned to photograph only objects which seemed to offer very little obvious visual stimulus, but to photograph them in a meticulous way on large format cameras (5×4inch and 10×8inch) —the working title had been *Banalities*. As the series progressed, however, he became increasingly concerned to evoke the air of decay which permeated this largely 19th-century area of London. Instead of showing a mundane view of the area, the majority of the photographs were darkly dramatic in a way reminiscent of Bill Brandt's photographs of the 1940s. Possibly the most remarkable aspect of *NW1* is that all but three of the fifty-one photographs are entirely devoid of people. This fact, and indeed the scope of the book in general, indicate to what extent Bailey's attitude to photography has been changing in recent times—to publish a body of work of this nature even a few years earlier would have been unthinkable. *NW1* was reviewed in the 'serious' magazines such as *Photographic Collector* and *Creative Camera* and for the cover of the latter Bailey also produced an excellent portrait of Bill Brandt.

In 1984 David Bailey is at a most interesting point in his career. His commercial work remains as effective and professional as ever, especially perhaps his continually innovative fashion photography for French and Italian *Vogue*. And he has added to this a new dimension in his work whereby he is producing self-motivated photographs of real excellence. The one area of operation supports and inspires the other and together they should ensure Bailey's wide acceptance as one of the leading British photographers of the twentieth century.

Technical note

Bailey graduated from a Box Brownie to cheap copies of the Rolleiflex (6×6cm) and the Leica (35mm rangefinder) while serving with the RAF in 1957. Since that time his fascination with the ways in which different camera formats affect photographic vision has led him to experiment with the widest imaginable range of equipment, from half-frame up to 11×14inch.

In the 1960s, after a short period when he explored the possibilities offered by his first 35mm single lens reflex camera, Bailey predominantly used 6×6cm cameras for most studio fashion and portrait photographs. Even then he would occasionally prefer 4×5inch or 10×8inch stand cameras, and much of his 'personal' work has continued to be made on these larger formats. For reportage work he has always favoured 35mm SLR cameras.

Today most of Bailey's commercial work is in colour, while his own projects are almost always shot in black and white. For some years he has printed his own black and white photographs and experimented with alternative processes such as gum-bichromate printing, print-out-prints, uranium toning and platinum printing.

Chronology

1938
Born 2 January in Leytonstone, London.

1953
Left school, aged fifteen.

1956–58
National Service, Royal Air Force, based in Singapore and Malaya.

1959
Assistant to John French, fashion photographer.

1960
First work for British *Vogue*.
Married Rosemary Bramble (later divorced).

1962
Worked for *Sunday Times* and *Vogue* editions in USA, France and Italy.

1965
Published first collection of portraits, *David Bailey's Box of pin-ups*.
Married Catherine Deneuve (later divorced).
Photographed complete December issue of British *Vogue*.

1966
Made film *G G Passion*.
Began producing and directing TV commercials and (from 1968) TV documentaries.

1969
Published *Goodbye Baby & Amen*.

1971
Exhibited at National Portrait Gallery, London.
Made *Beaton by Bailey* TV film.

1972
Elected Fellow of the Royal Photographic Society.

1973
One-man exhibition at the Photographers' Gallery, London.
Made TV film on Andy Warhol.

1975
Published *Another Image*.
Exhibition *A few more* at Asahi Pentax Gallery, London.
Married Marie Helvin.

1976
Co-founder of *Ritz* newspaper.

1980
The Boat People exhibition, Olympus Gallery, London.
Published *Trouble and Strife*.

1982
Published *NW1* and *David Bailey's book of photography*.

1983
Retrospective exhibition at The Victoria & Albert Museum, London.
Published *Black and White Memories*.

1984
Retrospective exhibition at the International Center of Photography, New York.

Bibliography

Books
David Bailey's Box of pin-ups, Weidenfeld & Nicholson, London, 1965.
Goodbye Baby & Amen, with text by Peter Evans, Condé Nast/Collins, London, 1969.
Beady Minces, MMD/Bailey, London, 1973.
Warhol by Bailey, MMD/Bailey, London, 1974.
Another Image: Papua New Guinea, MMD/Bailey, London, 1975.
Mixed Moments, Bailey/Olympus Optical, London, 1976.
Trouble and Strife, Thames & Hudson, London, 1980.
David Bailey's book of photography, JM Dent, London, 1982.
NW1, JM Dent, London, 1982.
Black & White Memories (1948–1969), JM Dent, London, 1983.

See also:
The Truth About Modelling, photographs by David Bailey with text by Jean Shrimpton, WH Allen, London, 1964
The Young Meteors, Jonathan Aitken, Secker & Warburg, London, 1967.
Hollywood England, Alexander Walker, Michael Joseph, London, 1974.
In Vogue, Georgina Howell, Allen Lane, London, 1975.
The Magic Image, Cecil Beaton and Gail Buckland, Weidenfeld and Nicholson, London, 1975.
Masterpieces of Erotic Photography, Talisman Books, London, 1977.
The Vogue Book of Fashion Photography, Polly Devlin, Thames & Hudson, London, 1979.
History of Fashion Photography, Nancy Hall-Duncan, Alpine, New York, 1979.
Fashion Theory, Carol di Grappa, Lustrum Press, New York, 1980.
Techniques of the World's Great Photographers, Phaidon Press, Oxford, 1981.
World Photography, Bryn Campbell, Hamlyn, London, 1981.
Master Photographers, Pat Booth, Macmillan, London, 1983.

Exhibitions
1971 National Portrait Gallery, London.
1972 Nikon Galerie, Paris.
1973 The Photographers' Gallery, London.
1980 Olympus Gallery, London.
1983 The Victoria & Albert Museum, London.
1984 International Center of Photography, New York.

Index of photographs

Author

Martin Harrison is director of the Olympus Gallery in London. He has worked as an assistant to a range of photographers—Beaton, Snowdon, Parkinson, Newton and Bailey himself. His previous books include *Burne-Jones* (1973, with B. Waters) and *Victorian Stained Glass* (1980). He contributed the biographical essay on David Bailey to the book *Black & White Memories* and the note on 'Bailey's Lighting' to the 1983 Victoria & Albert Museum exhibition catalogue.

Series Consultant Editors

Romeo Martinez has worked in photographic journalism for over 50 years. Resident in Paris, he is the author of several books on the history of photography and is the editor of the *Bibliothek der Photographie* series. He was responsible for the relaunch on the international market of the magazine *Camera*. From 1957 to 1965, he organized the biennial photographic exhibitions in Venice. Romeo Martinez organized the iconographic department at the Pompidou Centre in Paris. He is a member of the Administration Council and of the Art Commission of the Societé Français de Photographie and a member of the Deutsche Gesellschaft für Photographie.

Bryn Campbell has been active both as a professional photographer and as an editor and writer on photography. He is known to many as the presenter of the BBC TV series *Exploring Photography*. As a photographer, he has worked for a Fleet Street agency, with *The Observer*, and on assignments for *Geo* and *The Observer Magazine*. He has been Assistant Editor of *Practical Photography* and of *Photo News Weekly*, Editor of *Cameras & Equipment*, Deputy Editor of *The British Journal of Photography* and, from 1964 to 1966, Picture Editor of *The Observer*.

In 1974 he was made an Honorary Associate Lecturer in Photographic Arts at the Polytechnic of Central London. The same year he was appointed a Trustee of the Photographers' Gallery, London. He served on the Photography Sub-Committee of the Arts Council and later became a member of the Art Panel. He is a Fellow of the Institute of Incorporated Photographers and a Fellow of the Royal Photographic Society. His book *World Photography* was published in 1981.

First published in 1984 by
William Collins Sons & Co Ltd

London · Glasgow · Sydney
Auckland · Johannesburg

© 1983 Gruppo Editoriale Fabbri S.p.A., Milan

ISBN 0 00 411954 1

Typesetting by Chambers Wallace, London
Printed in Italy